THE
Archive Photographs
SERIES

GREAT WESTERN
SWINDON

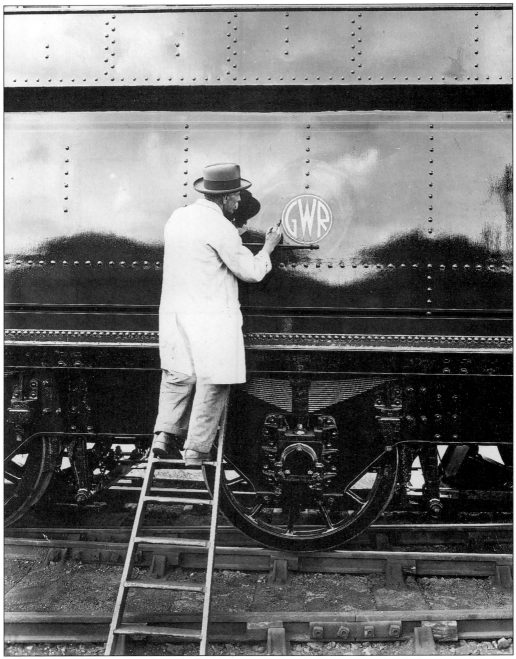

A Great Western signwriter adds the final touches to the new roundel badge introduced in 1934.

THE
Archive Photographs
SERIES

GREAT WESTERN
SWINDON

Compiled by
Tim Bryan

CHALFORD

First published 1995
Copyright © Tim Bryan, 1995

The Chalford Publishing Company
St Mary's Mill, Chalford,
Stroud, Gloucestershire, GL6 8NX

ISBN 0 7524 0153 X

Typesetting and origination by
The Chalford Publishing Company
Printed in Great Britain by
Redwood Books, Trowbridge

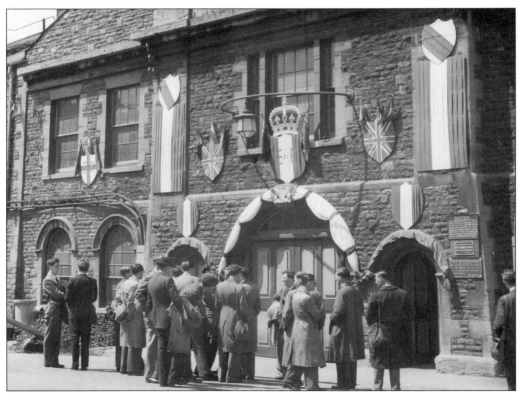

Schoolboys wait outside the entrance to Swindon Works before their Wednesday afternoon tour on 16 June 1953.

Contents

Acknowledgements

Thanks are due to a number of people for their assistance in the compilation of this volume:
Brian Bridgeman, Robert Dickinson, Maurice Edwards, Jack Hayward, Iain Steel
and John Walter.

As always, the staff of the Reference Library at Swindon were helpful, and thanks are also due
to Gary Bond, Development Manager of Tarmac (Swindon) Limited.
Mention should also be made to the staff of the GWR Museum itself, Elizabeth Day,
Marion Flanagan, Marion Robins, Neil Swatton and Christine Warren.

All 'official' photographs are used by courtesy of the National Railway Museum in York.

Finally, I would also like to thank David Hyde, who through the hours of patient work he
contributed in sorting and identifying many of the pictures contained in this book, made my
task of compiling this book very much easier.

Introduction

It hardly seems possible that Swindon Works, which for so long dominated the history and fortunes of the town of Swindon, will have been closed almost ten years by the time this book is published. This book does not attempt to give a history of the workshops, or the Company that founded them, since many books have already been written on the subject. What this collection will hopefully do, however, is to give the reader a portrait of the huge empire that the works created, both inside and outside its forbidding walls.

The story of the Great Western at Swindon is one not only of engineering excellence, but also of a tight knit community which grew up around the railway workshops, and expanded as the fortunes of the Great Western Railway grew. Above all the pictures in this book reflect not only the machines and equipment which made Swindon famous the world over, but also the people behind those machines. At its height the works employed over 12,000 people, and many more depended on the factory for their livelihood.

The pictures contained in this volume come from a variety of sources, but all form part of the collection of the Great Western Railway Museum in Swindon. Opened in 1962, the museum does more than just display famous locomotives like *King George V*; it is actively collecting material on all aspects of the Great Western Railway and Swindon. Its photographic archive includes material taken by the Company's own photographers, and a variety of other sources such as retired railway staff and postcard photographers. Plans are well advanced to move the existing museum, which is currently housed in the old Wesleyan Chapel building in Faringdon Road, into one of the workshops on the old Railway Works site, now being comprehensively redeveloped by Tarmac (Swindon) Limited. With the opening of this new larger museum, Swindon's railway heritage, so vividly illustrated in this book, will be truly honoured for future generations to appreciate.

Tim Bryan
Swindon
May 1995

One
Swindon Junction

The station at Swindon was the first Great Western facility to open in the town, although its early history was tarnished by the fortunes of the Refreshment Rooms set up on the station when it opened in 1841. The story of these rooms has been told countless times in other books, and has probably been the root of the many jokes about railway catering ever since. The station was renamed Swindon Junction to avoid confusion with Swindon Town station opened by the Midland & South Western Junction Railway in 1881.

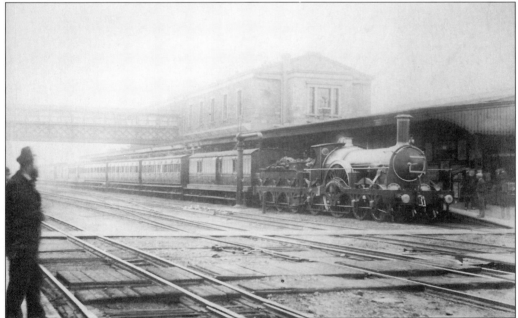

The scene at Swindon Junction in May 1892, as spectators gather to watch the passage of one of the last broad gauge trains through the station. Remnants of Brunel's great experiment lingered for some further time, since most of the broad gauge rolling stock was either scrapped or converted at the works.

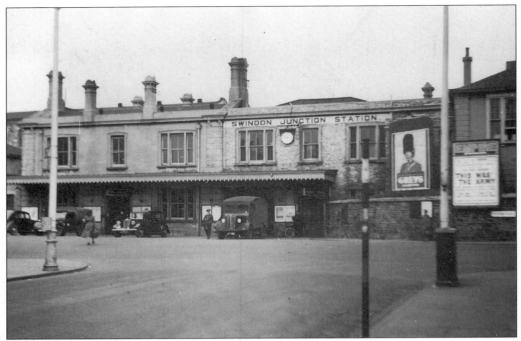

The frontage of Swindon station in the 1950s. In comparison to other stations on the GWR, its architecture was relatively unassuming.

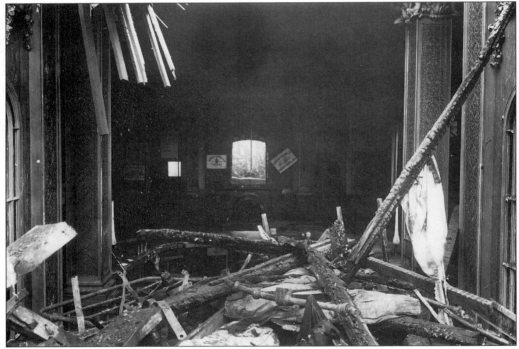

The aftermath of a serious fire at Swindon in 1898, which led to the closure of the hotel which had been operating on the station.

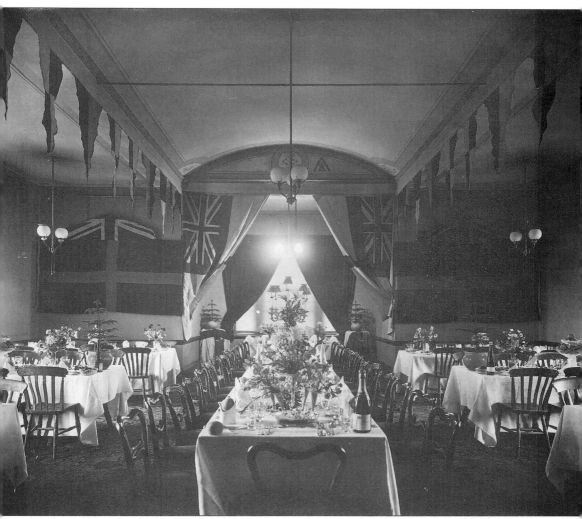

One of the banqueting rooms at Swindon Junction as seen on 25 January 1911. No indication of the occasion being celebrated has survived. After the fire illustrated in the previous photograph, the upper floors of the station were refurbished, and many annual dinners and other special occasions were held on the premises.

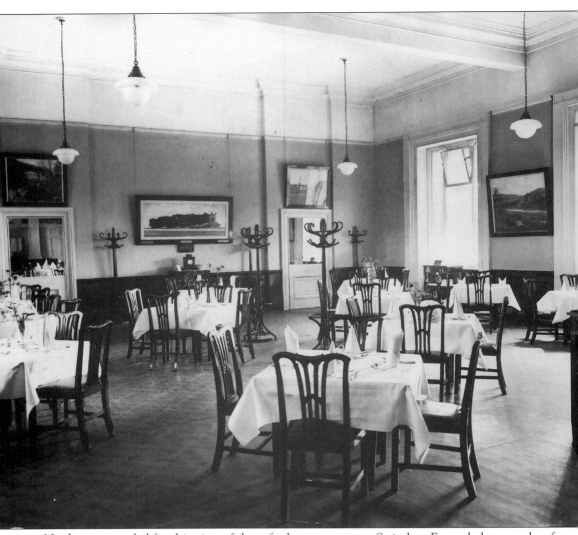

No date is recorded for this view of the refreshment rooms at Swindon. Framed photographs of GWR holiday destinations hang from the walls, with the Fishguard Bay Hotel seen in the picture on the far left.

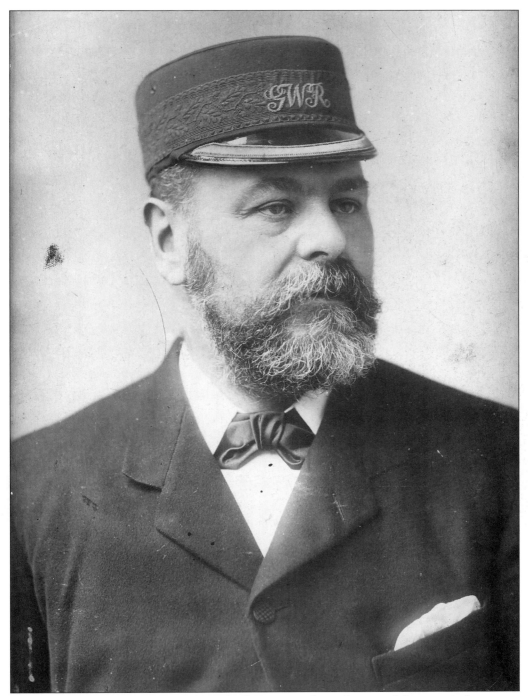

Mr John Brewer, Stationmaster at Swindon Junction in the early years of the twentieth century. An article on the station published in 1901 noted that he began his railway career in 1859, working for the South Devon, Cornwall and West Cornwall railways. No less than 230 staff were under his control, including over 40 employed in the refreshment rooms.

The rather makeshift anti-aircraft post situated on the roof of the station during the Second World War. The larger station noticeboards, removed early in the war, have been replaced by smaller enamel notices, one of which can be seen close to the way out sign.

The subway linking the station entrance to the island platforms, as seen in January 1970. With the modernisation of the station, the tunnel has been somewhat improved.

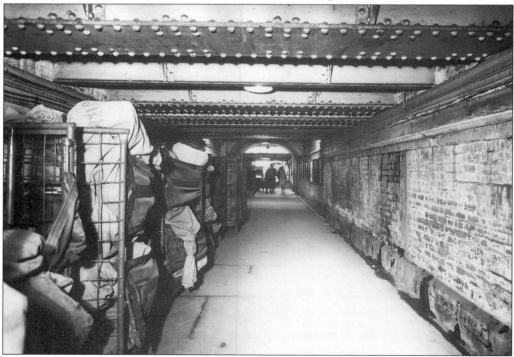

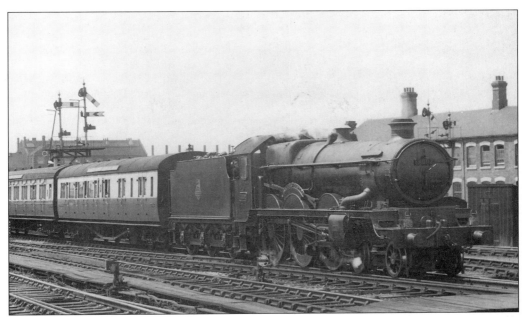

'Castle' class No.7002 *Devizes Castle* brings an express into Swindon Junction in June 1963. The Carriage Works offices can be seen in the background.

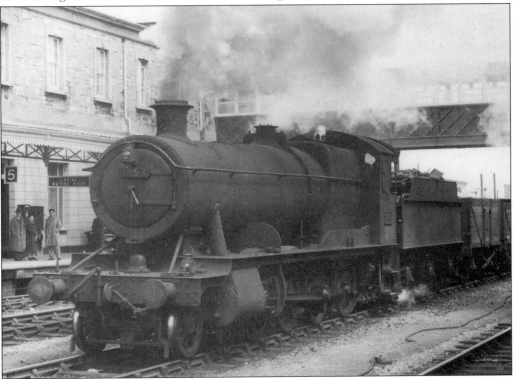

Collett 2–8–0 No. 3853, built in June 1942 trundles an unfitted freight through Swindon on 16 June 1963.

The view west from Swindon Junction in September 1895. Lines of locomotives ready to enter the works can be seen in the distance; the one-storey building on the right of the photograph is the site of the first Medical Fund swimming baths.

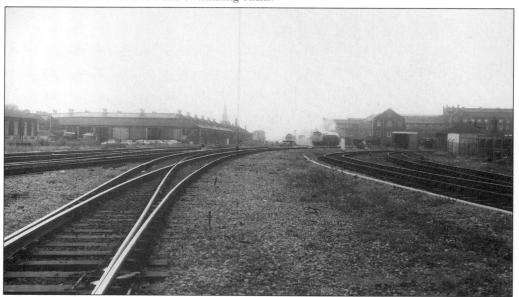

A very similar view taken in 1969. The General Offices buildings in the background have acquired another storey, and the steam locomotives have been replaced by Swindon built diesels.

Two

The Locomotive Works

The Works at Swindon began operation in January 1843, only initially intended as a repair facility. Soon the operation grew, and the first engine built at Swindon aptly named the Great Western *was constructed in 1846. By the 1930's the Locomotive Department at Swindon employed around 7,000 men, with the capability to build around two engines a week, and repair over a thousand engines per year. To assist the reader it is worth remembering that all workshops on the locomotive side were identified with letters, whilst those in the Carriage Works were marked by numbers.*

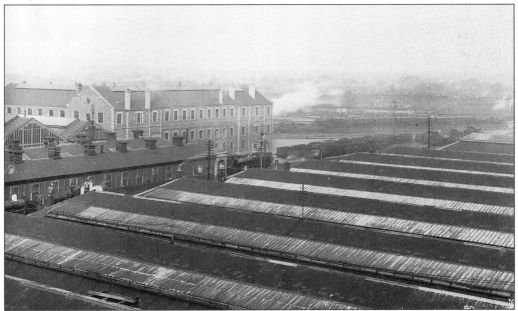

Perched on the roof of the Carriage Works, the photographer has pointed his camera North East recording the newly extended General Offices building, and to its left, the 'B' Shed complex.

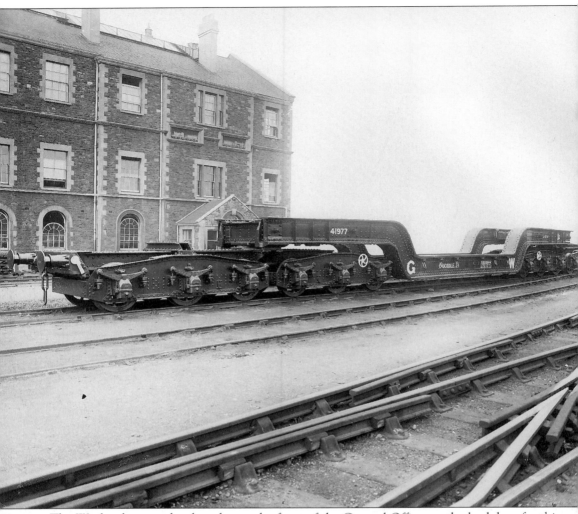

The Works photographer has chosen the front of the General Offices as the backdrop for this portrait of a Great Western 'Crocodile' bogie wagon, used for the transportation of heavy and awkward loads. Above the main entrance to the building, the two likenesses of GWR 'Firefly' class locomotives can be seen. As early as 1900, this building was fitted with double-glazed sash windows, in attempt to cut down noise as well as retain heat.

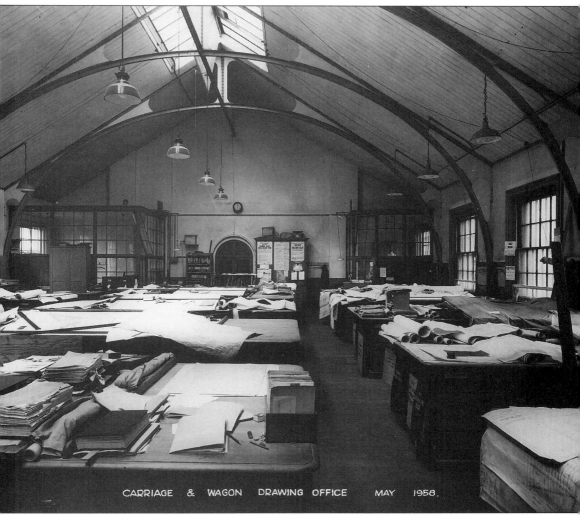

CARRIAGE & WAGON DRAWING OFFICE MAY 1958.

The Carriage & Wagon Drawing Office in May 1958. These spacious rooms were added in the early years of the twentieth century; on the right of the picture, large diagram books, containing drawings of rolling stock hang from the ends of the plan cabinets. The drawing office is now the Library of the Royal Commission on the Historic Monuments of England, who occupy the refurbished General Offices complex.

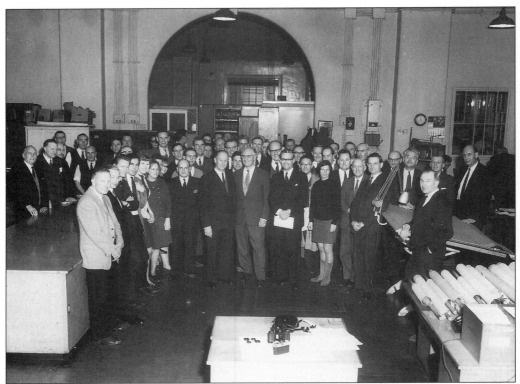

The staff of the Drawing Office on the occasion of the retirement of Mr H.J. Rideout, Chief Draughtsman. No date is given on the picture, but the fashions suggest the mid 1960s.

The General Offices also housed the office of the Chief Mechanical Engineer; seen here is the last incumbent of the post in GWR days, F.W. Hawksworth, who succeeded C.B. Collett in 1941.

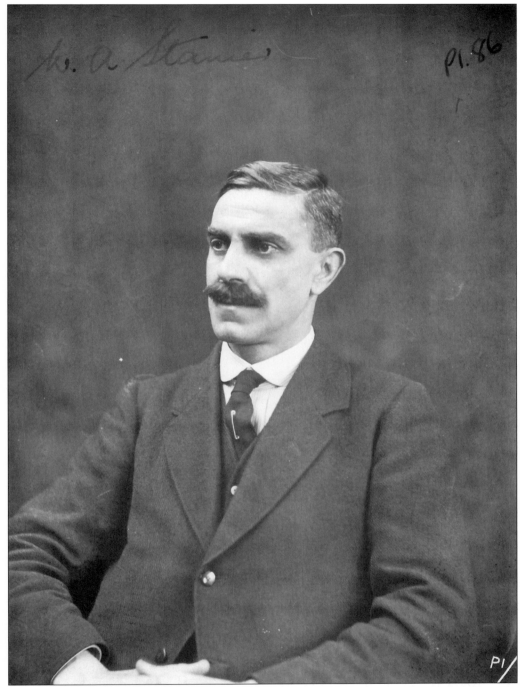

W.A. Stanier, Locomotive Works Manager from 1923 to 1932. In that year he was appointed as Chief Mechanical Engineer to the London Midland and Scottish Railway, ensuring that the Swindon influence spread much further north.

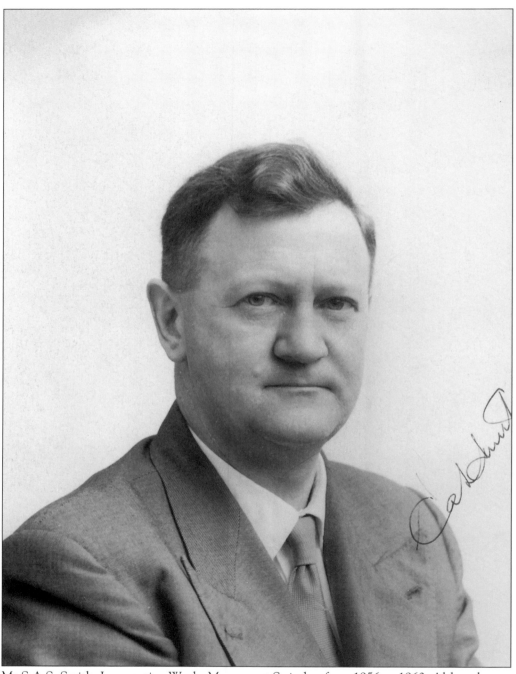

Mr S.A.S. Smith, Locomotive Works Manager at Swindon from 1956 to 1960. Although now living away from Swindon, as President of the Friends of Swindon Railway Museum he still keeps in touch with events in the town.

The original Engine House built by Daniel Gooch in the early 1840s was finally demolished in 1930, and the 'B' shed which lay behind it was extended. Work on the alterations is well under way in this picture, and the repair of locomotives continues uninterrupted in the workshop itself.

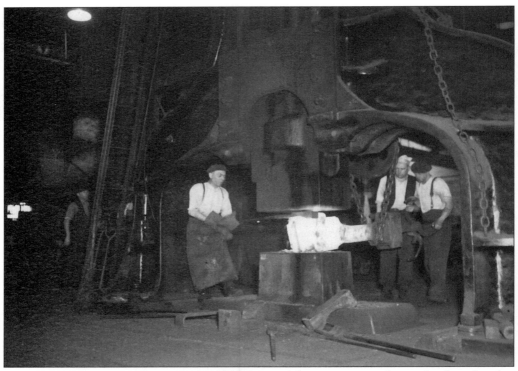

A locomotive coupling rod is forged under one of the large steam hammers in October 1947.

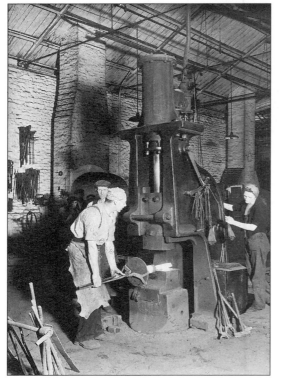

Smaller steam hammers were used on locomotive components. This 10 cwt. example is being used to forge an engine buffer on 28 April 1942. The hammer driver is a woman, one of many employed in the works during the Second World War.

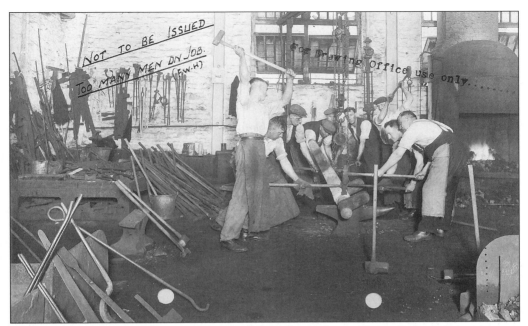

The annotations on this photograph, rescued from the works, need very little comment!

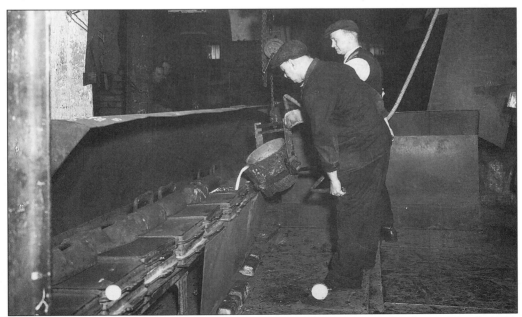

Molten metal is poured into moulds in the Brass Foundry in a photograph taken in March 1954.

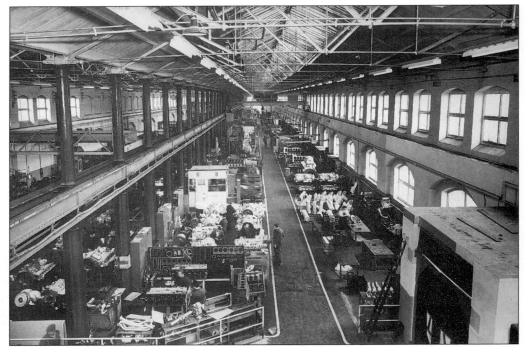

The largest foundry on the site was the J1 Iron Foundry. With the end of steam locomotive production and repairs, the building was converted into a diesel engine fitting shop

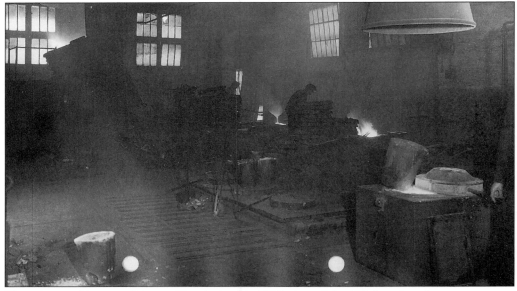

Victorian working conditions still exist in this 1953 view of the 'U' shop foundry.

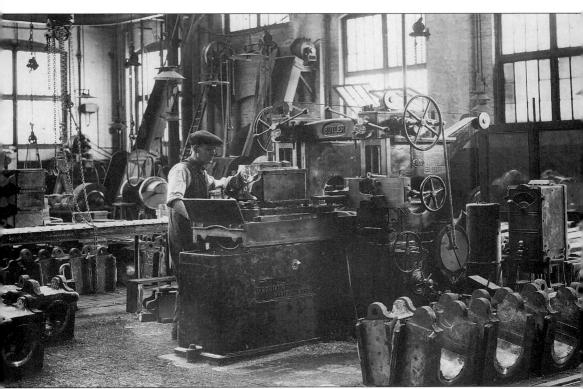

The railway workshops possessed a number of machine shops in both the Locomotive and Carriage departments. This photograph of a Butlers axlebox planing machine was taken in the 'AM' shop in June 1934.

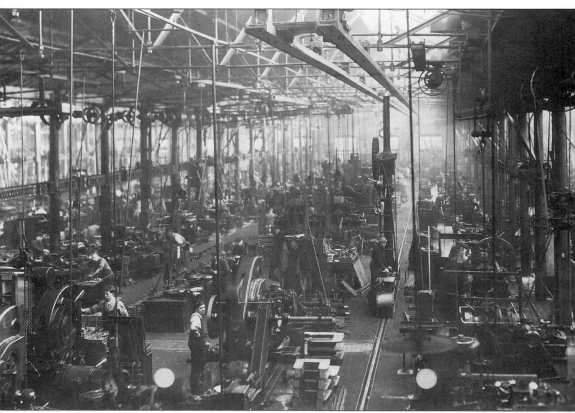

The 'R' machine shop in December 1945. The workshop was filled with all manner of lathes, borers, grinders and other equipment, which was used to machine castings and forgings into shape. This building is to be the site of the new Swindon Railway Heritage Centre, a museum which will celebrate the role of Swindon in the success of 'Gods Wonderful Railway'.

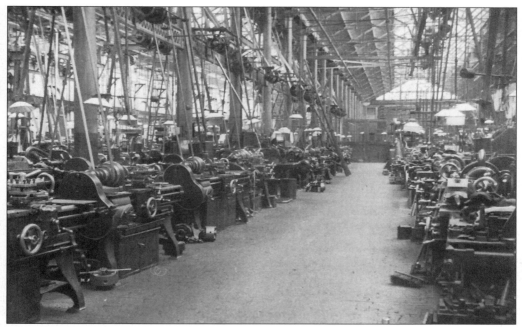

An early view of the 'O' shop, showing many of the belt driven machines.

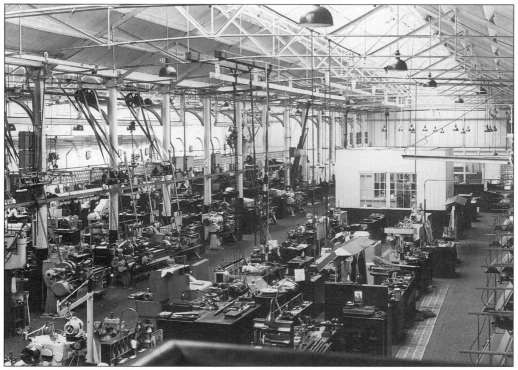

A later view of the 'O' shop, taken in the 1950s. This workshop was the tool room of the workshops, and was used to produce many of the precision tools and gauges used in the complex.

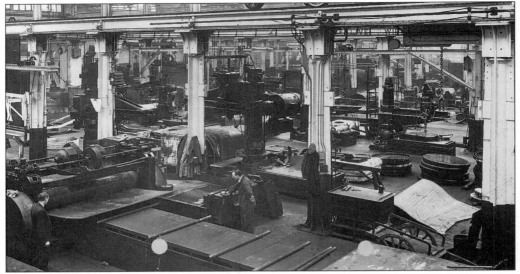

A general view of the 'V' Boiler shop, showing work in progress on the 5 January 1954.

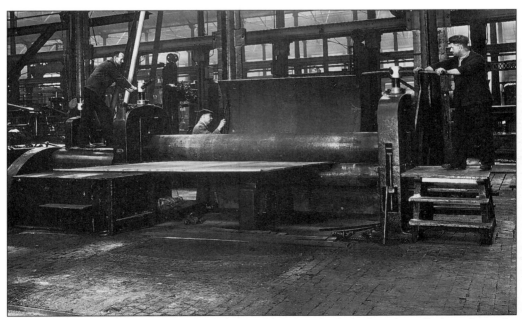

GWR boilers were constructed of thick metal plate, which had to be rolled to form the cylindrical barrel of the boiler itself. The machine for doing this is seen in action in October 1939.

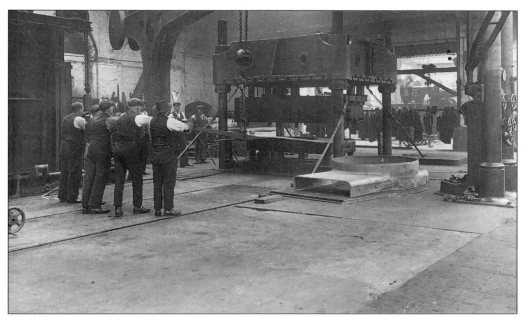

One of the powerful hydraulic presses used to form boiler throat plates. The metal has been heated up in the furnace to the left of the picture, and is being manoeuvred into place under the press. In the background the coats and hats of the workmen can be seen hanging on the communal coatrack.

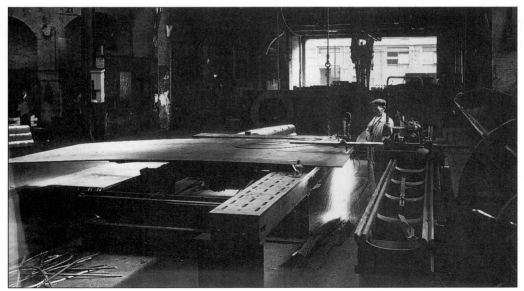

Steel plate being cut to shape in the Boiler shop in September 1939.

An atmospheric view of the check board and staff notice board in the 'B' Shed in 1930. Brass checks were used for timekeeping purposes, and are now highly prized by railway collectors. One of the notices above the board warns staff to use eye protectors when operating machinery.

The Lamp House in the 'K' Shop with large numbers of railway lamps in the course of construction and repair. This view was taken in April 1954.

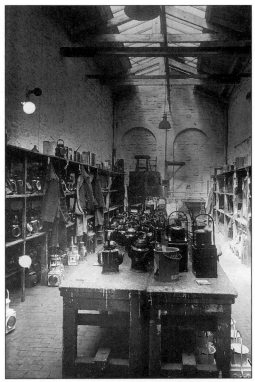

All manner of work is going on in this view of the 'T' shop in this photograph taken on the same day as the previous picture. The sheer clutter in the workshop is worthy of mention!

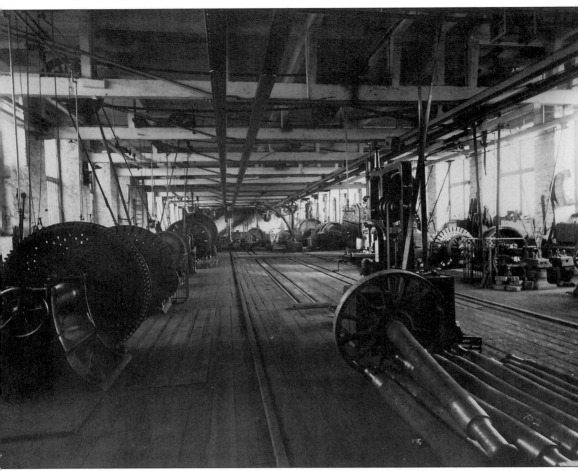

The Wheel shop in 1911. This view shows the original shop where wheels and axles were united, and where the steel tyres were turned on belt driven lathes of fairly elderly vintage. With the opening of the 'A' shop in the early years of the twentieth century, more modern facilities were available.

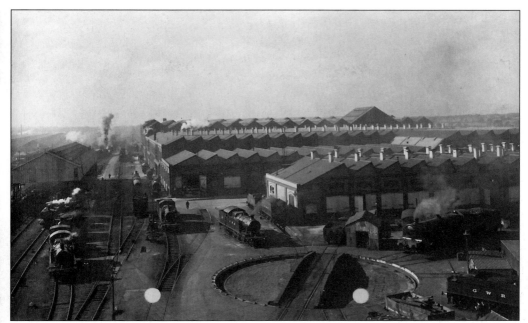

A general view of the exterior of the 'A' shop taken in October 1945. The workshop was built in two stages, the first section opening in 1900, the second just after the Great War.

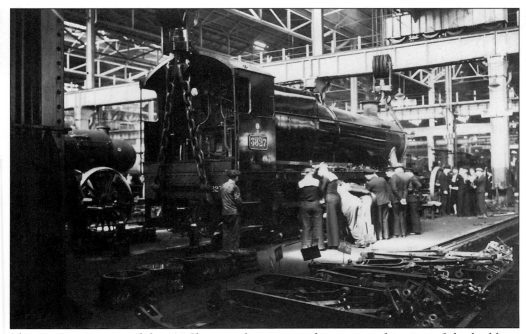

The spacious interior of the 'A' Shop can be seen to advantage in this view of the building, taken when the crew of HMS *Australia* visited the works on the 13 July 1945.

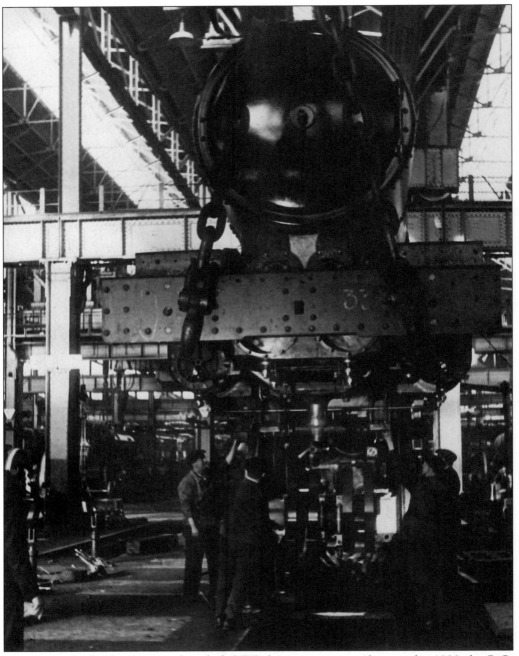

This view of 'wheeling' an unidentified GWR locomotive was taken in the 1930s by R.G. Hannington, Works Manager from 1922 to 1937.

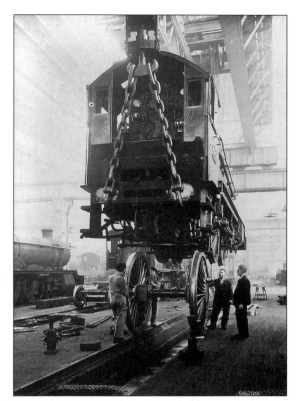

The reverse process to the previous picture, with a 'Castle' class locomotive being 'unwheeled' in the 'A' shop on 6 October 1947.

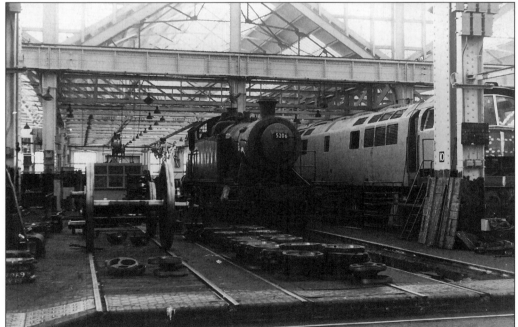

A Churchward 42xx 2–8–0 tank No. 5206 is seen under repair in the 'A' Shop on 29 July 1962. Evidence of the changing climate can be seen with the 'Western' class diesel in the next bay.

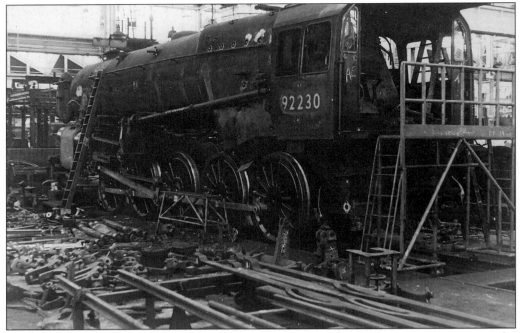

Photographed on the same day as the previous picture, BR 9F 2–10–0 No. 92230 is seen under repair in the 'A' Shop.

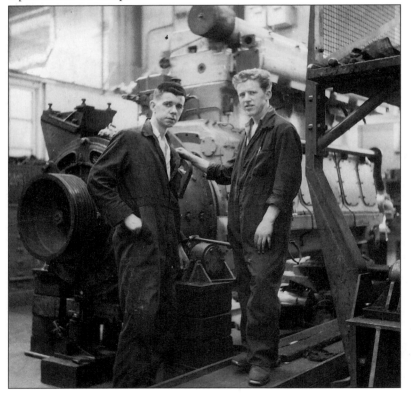

Two unidentified apprentices pictured next to one of the engines from a BR diesel locomotive in the late 1950s.

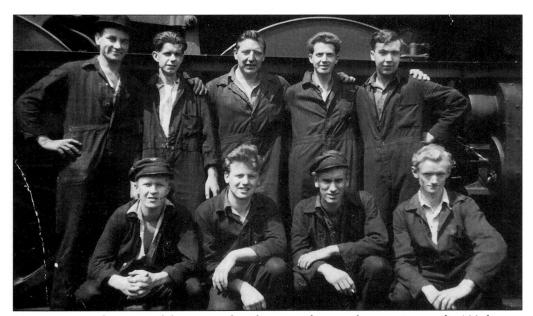

It was common for many of the gangs of workmen working on locomotives in the 'A' shop to pose in front of the engines they built and maintained. Unfortunately there are no names on the back of this picture, but hopefully readers will be able to recognise some familiar faces.

In the 1930s the 'A' shop was also used for the maintenance of GWR Diesel Railcars, where the large overhead cranes could be used to lift the body of the vehicle with ease. This photograph shows the first of the class, Railcar No. 1, which was built in 1934 by AEC at Southall.

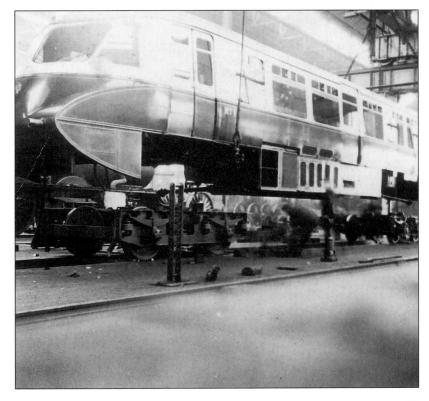

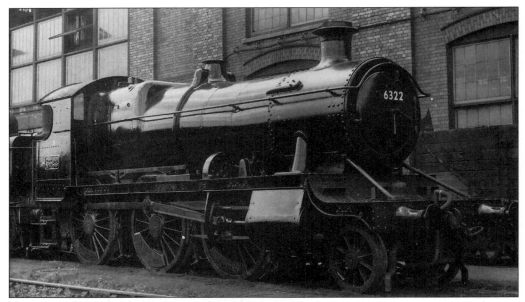

For many trainspotters, the sidings which ran alongside the 'A' Shop were a mecca, and many caught the 'Old Town Bunk' as it was known, which ran from Swindon Junction to Swindon Town station, in order to look out of the window at the engines outside the works. 2–6–0 No. 6322 is seen outside the 'A' Shop in the 1960s.

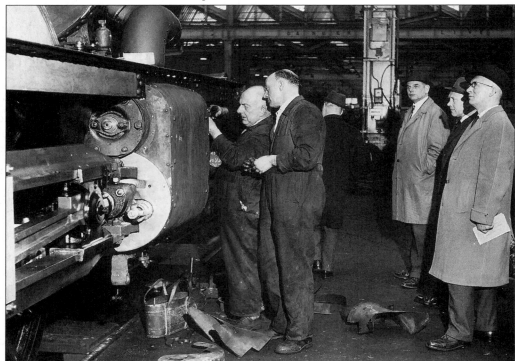

The workmen seen here are under the watchful eye of the Western area board of British Railways, who visited the works on the 16 February 1965.

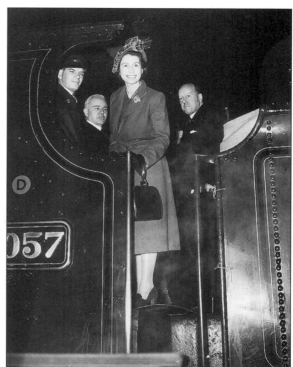

A more famous visitor, H.R.H. Princess Elizabeth, on the footplate of the locomotive bearing her name, when she visited the workshops on 15 November 1950.

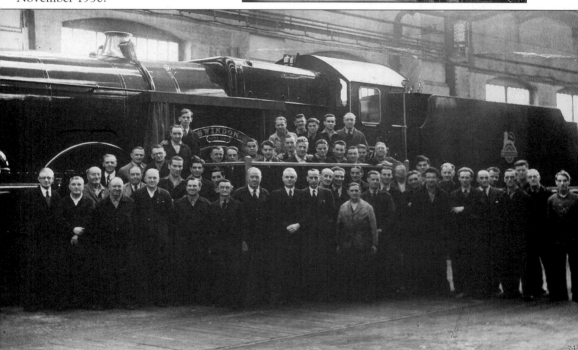

Workmen involved in the construction of the last 'Castle' class engine No. 7037 *Swindon* constructed in the works, which Princess Elizabeth formally named during her 1950 visit.

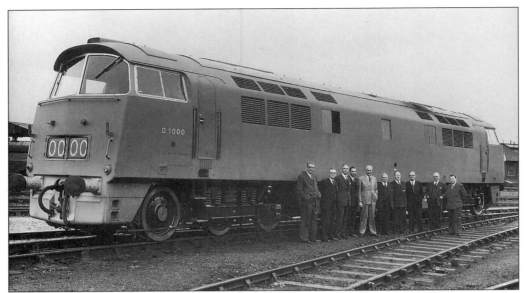

A group of officials including Works Manager S.A.S. Smith stand in front of the first 'Western' class Diesel Hydraulic Locomotive No. 1000. The engine has yet to receive proper numberplates and its name, *Western Enterprise*.

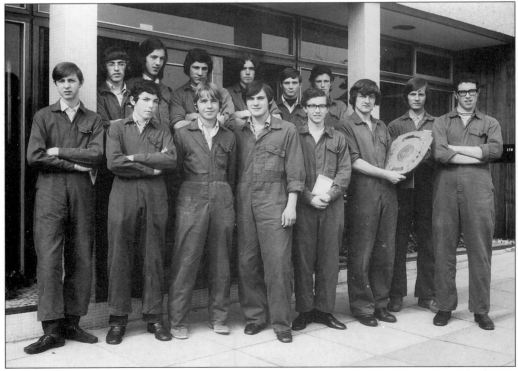

A group of Swindon Apprentices stand in front of the Diesel Training School, which was situated in Newburn Crescent. Even this relatively modern photograph is almost 25 years old, having been taken in September 1970.

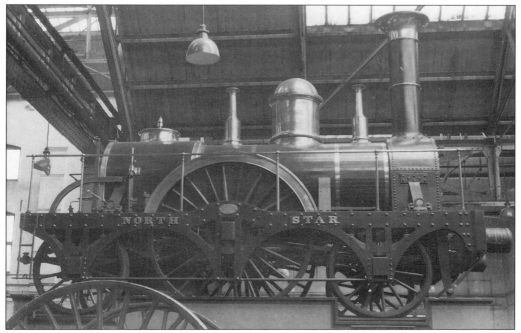

The replica broad gauge locomotive *North Star* was for many years placed on a plinth and displayed in the 'A' Shop, before becoming one of the exhibits within the G.W.R. Museum when it opened in 1962.

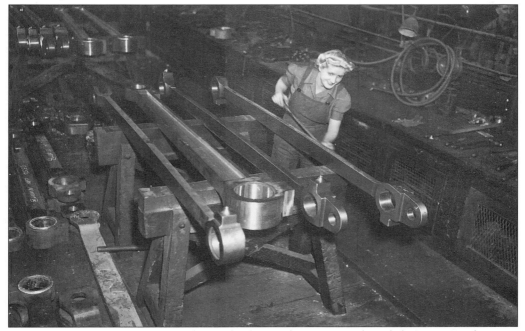

Many women were employed in the works during the war period, and this picture taken two years after the end of hostilities shows locomotive connecting rods being 'finished'. This process involved filing and sanding to buff the rods up before being returned to locomotives.

Some idea of the scale of the Swindon operation can be seen by the large number of locomotive tyres and wheels in this 1951 picture.

The company photographer was called in February 1930 to record this extraordinary selection of bent and damaged engine connecting rods.

All around the works, war memorials to those who had fallen in both World Wars were to be found, and this Hooper postcard records one of the annual remembrance services held in the 'A' shop just after the Great War. On these occasions, widows and families of those lost in the conflict were also part of the assembled crowd.

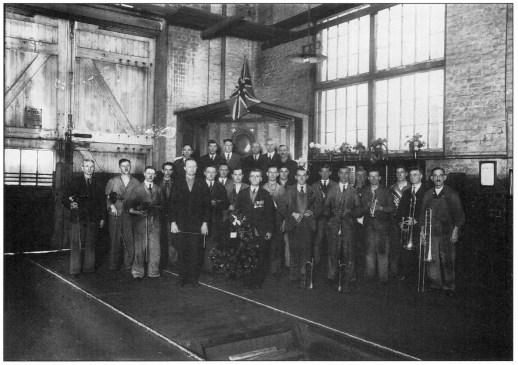

The band assembled for the 'A' shop ceremony in November 1938.

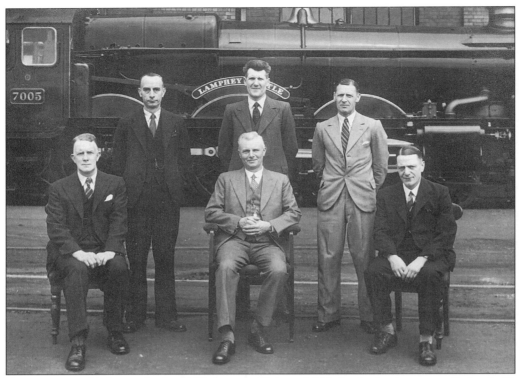

Foremen assembled outside the 'AE' shop on 23 June 1946. In the back row are P. Jarvis, S. Abrams and C.H. Keefe. In the front row are seated J. Owen, S. Millard and J. Gregory.

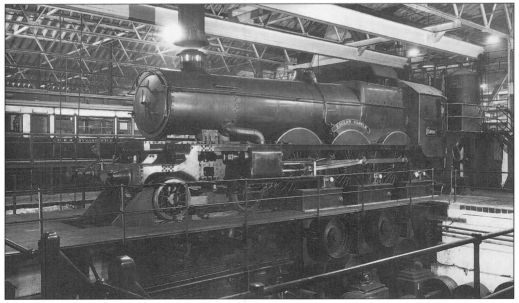

One unique feature of the works was that it had a testing plant which allowed locomotives to be run at high speed. No. 5008 *Raglan Castle* is seen on the 'Home Trainer' as it was nicknamed in May 1928.

The gardens of houses in Redcliffe Street backed right onto the high brick wall which marked the edge of company property. Washing can be seen hanging on some lines in this 1951 view, although with the smoky atmosphere, how clean it stayed is debatable!

Over the years large amounts of ash were tipped at the works to raise the level of the land. This highly combustible material caused great concern, especially when bank fires occurred, as on this occasion in 1951.

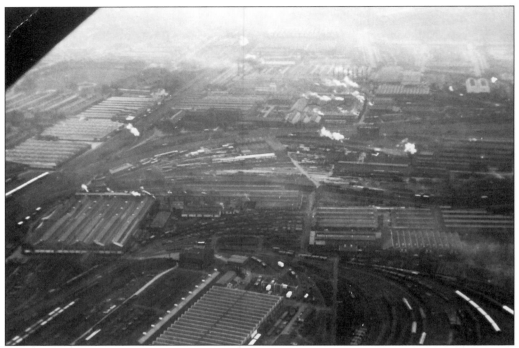

An aerial view of the works taken between the wars. The caption scribbled on the back of the picture notes that it was taken from an aeroplane flying at 900 feet.

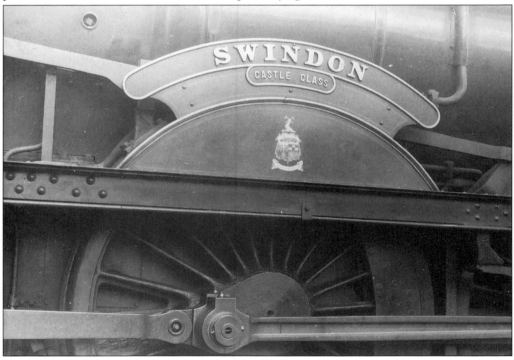

The nameplate of 'Castle' class locomotive No. 7037 *Swindon*, built in 1950.

Three
The Carriage and Wagon Works

Established in 1868, this part of the Company's operation was mostly situated on the south side of the main Bristol–London Main line, and employed around 5,300 people. Building over 250 coaches a year at its height, the Carriage Works could also repair a staggering 5,000 carriages and 8,000 wagons as well.

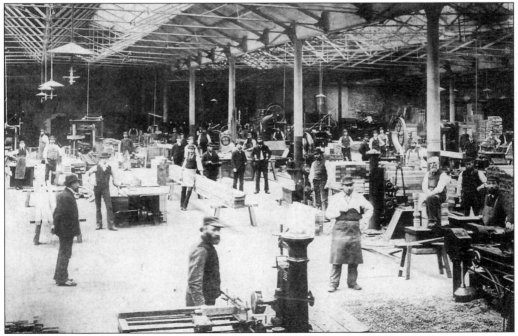

An early view of the No. 2 Sawmill, probably taken around 1880.

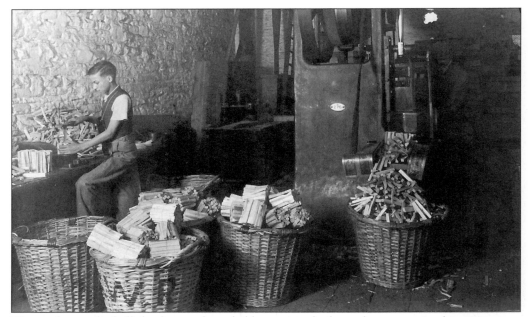

The works supplied all the firewood needed by engine sheds on the system. In this 1934 view, an extremely young apprentice is seen bundling up the trimmed wood in the sawmill.

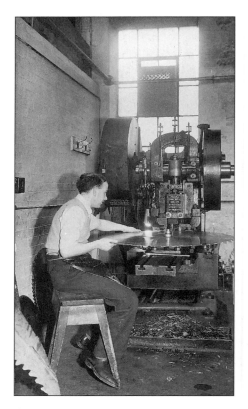

An essential element of the Carriage & Wagon Works was the provision of sharp saw blades. By 1953 a machine had been introduced to help in this task, and another apprentice is seen sharpening and setting a circular saw blade.

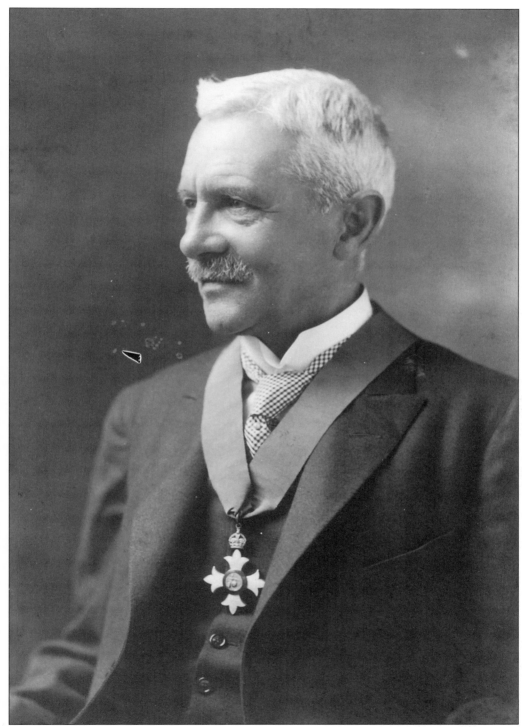

F.W. Marillier, Carriage Works Manager from 1902 to 1920. He was much involved in the construction of Ambulance Trains during the First World War.

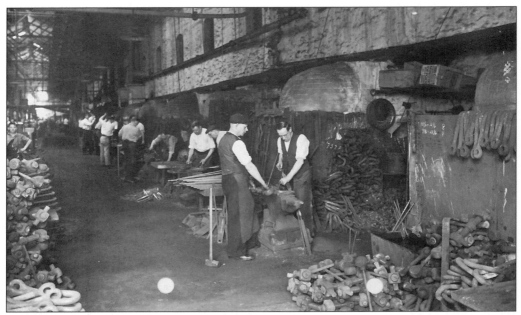

Conditions in the Blacksmiths Shop (14 Shop) have probably changed little in 50 or so years, judging by this 1945 view.

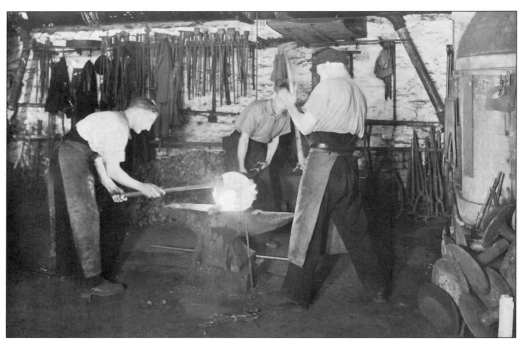

Another photograph typifying the sheer hard work involved in the production of locomotives and rolling stock; a buffer shank is being welded in this 1942 scene. The wide range of specialised tools used by the blacksmiths can be seen hanging on the wall behind the men.

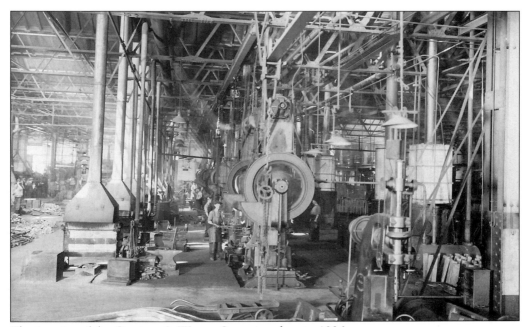

The interior of the Carriage & Wagon Stamping shop in 1936.

Staff pictured outside No.1 Shop, Carriage & Wagon Works around 1935.

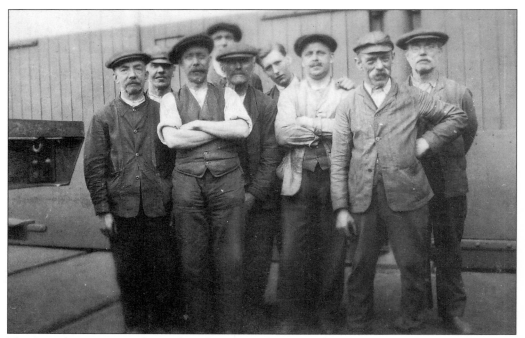

The first of two pictures chronicling the career of Mr H.G. (Bert) Moody, a chargehand fitter in No. 15 (Fitting & Machine) Shop. This view shows a very young Bert peeping through the middle of this group taken sometime in the late 1920s.

The second picture was taken in February 1960 on the occasion of his retirement. Mr Moody can be seen fourth from the left. No other names are recorded in this jovial group.

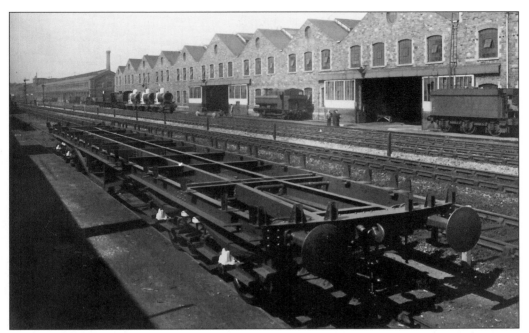

The underframe of 3rd Class corridor carriage No. 1691 can be clearly seen in this 1945 photograph. Across the tracks, locomotives stand outside the 'B' shed awaiting attention.

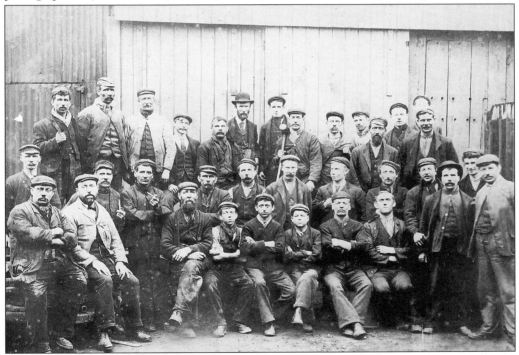

The museum possesses a number of photographs similar to this one, showing groups of workmen outside workshops in the Carriage Department. No date or location is given for this picture, although it was probably taken around 1900.

The interior of the Carriage Trim Shop, Christmas 1938.

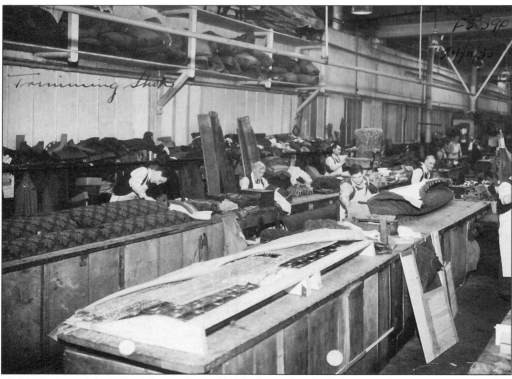

A 1953 view of the Trim Shop, where all upholstered and fabric parts of carriages were made.

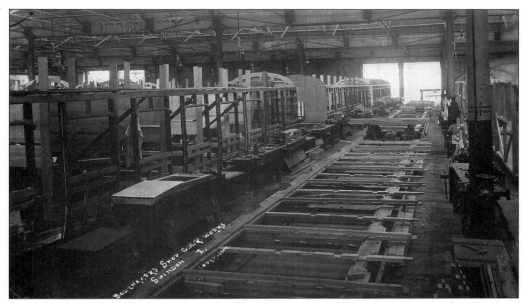

A postcard view of the Carriage Body Shop, taken by the Swindon photographer William Hooper, sometime before the First World War.

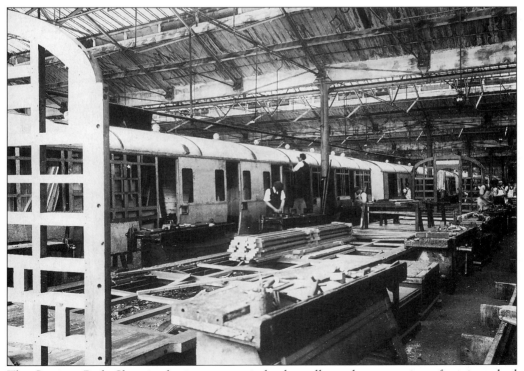

The Carriage Body Shop in the interwar period, when all wood construction of carriages had ceased, and steel panelling had replaced wood for carriage sides.

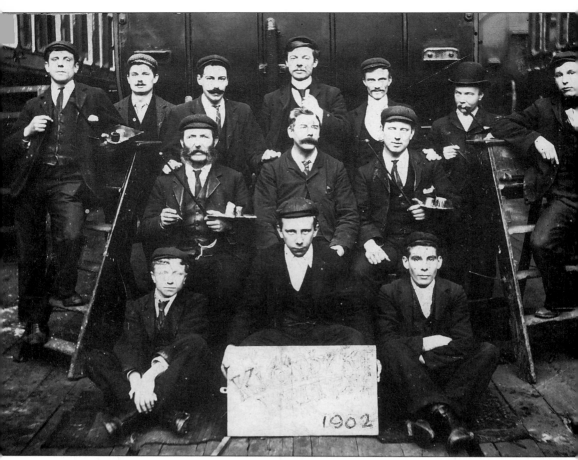

A wonderful photograph of the signwriters on the staff of the Carriage Works paint shop. The board held by the young man in the front row reads 'Klondyke Writers 1902'. Names are given for those in the picture from back to front. The names were: A. Jeramed, G. Turner, F. Cavill, W. Wakefield, C. Dowley, A. Andrews, I. Norton, P. Collins, E. Raliegh, H. Wakefield, S. Pearce, S. Hobbs, and A. Stanley.

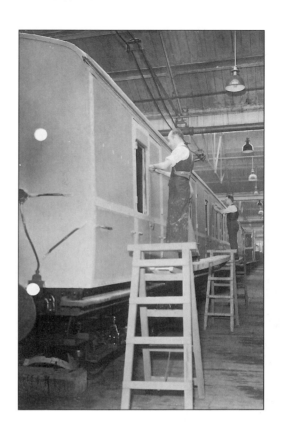

The Carriage Paint Shop December 1953.

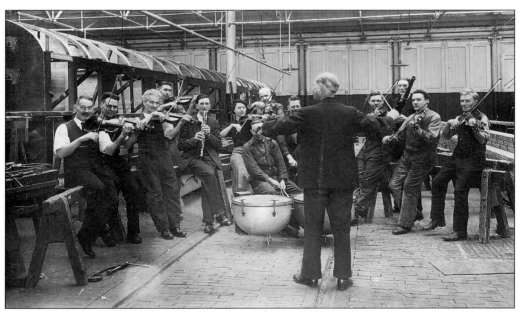

A print taken by the Drawing Office at Swindon presumably for publicity purposes. The GWR Staff Orchestra are practising in the Carriage Body Shop in March 1938.

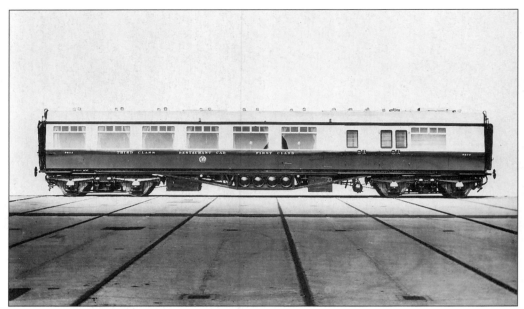

Swindon craftsmanship: GWR Restaurant Car No. 9602 built in August 1939.

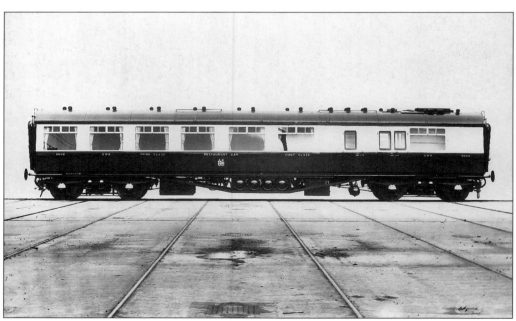

A Hawksworth designed Restaurant car No. 9606, built at Swindon in February 1946.

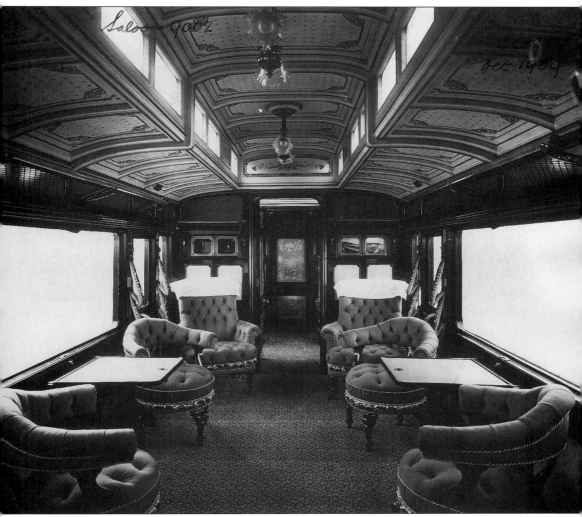

Victorian Grandeur: the interior of GWR saloon No. 9002, photographed in October 1909.

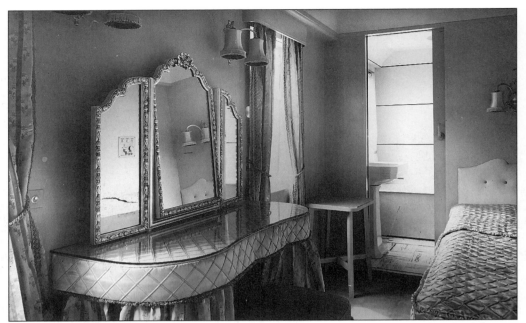

Two photographs from an album of pictures presented to the museum giving details of the two royal carriages built for the Queen Mother in 1944. This view shows one of the bedrooms in saloon No. 9007.

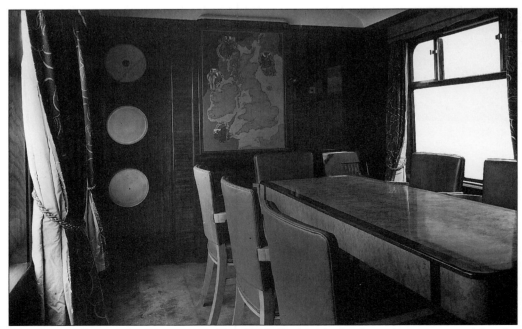

The Dining Room of sister carriage No. 9006. Both vehicles have been preserved by the National Railway Museum at York.

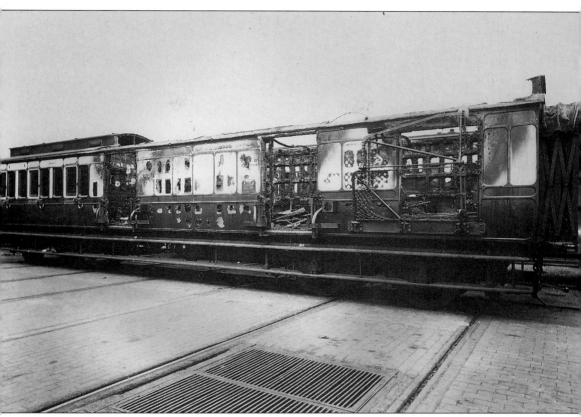

Periodically Swindon was called on to scrap or repair vehicles involved in accidents or other mishaps. No details are given as to the fate of this mail van, photographed in the works in June 1894.

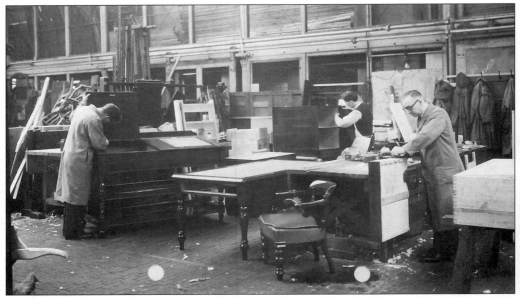

The Carpenters Shop was regarded as the 'Utility Shop' of the Works, and all manner of work was carried out here. Furniture, station equipment and barrows were all made and repaired here. This picture was taken in 1953.

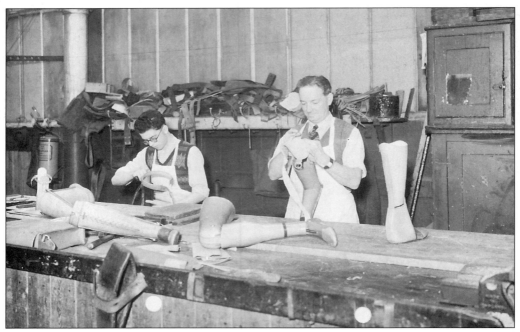

A less publicised task undertaken by the Carriage Department was the provision of artificial limbs for those staff unfortunate enough to lose limbs whilst in the company's service.

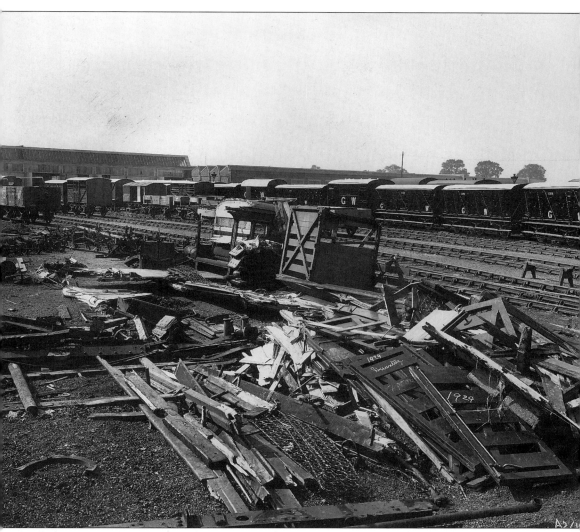

Much less attention is paid to the output of the Wagon Works, which over the years built thousands of vehicles for the Company. This 1916 picture, taken to illustrate the remains of a badly damaged carriage in the foreground, does actually reveal an interesting selection of wagons in the background.

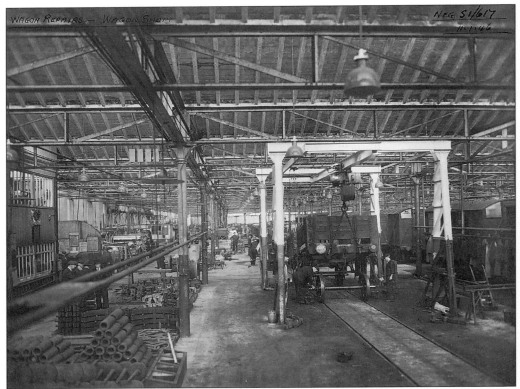

The interior of the Wagon Repair shop, in a photograph taken in 1946.

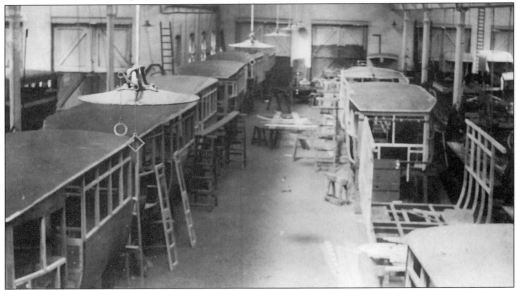

Although of poor quality, this postcard view of the Road Wagon Shop is of interest, since few pictures survive of this location. Initially set up to build and maintain the horse drawn vehicles owned by the company, by the time this picture was taken in May 1925 it had begun to build the bodies of motor vehicles as well.

Four

Miscellaneous Service

One boast of the Company was that the Railway Works at Swindon were almost self sufficient. An empire within an empire, all manner of services and facilities were available within the factory.

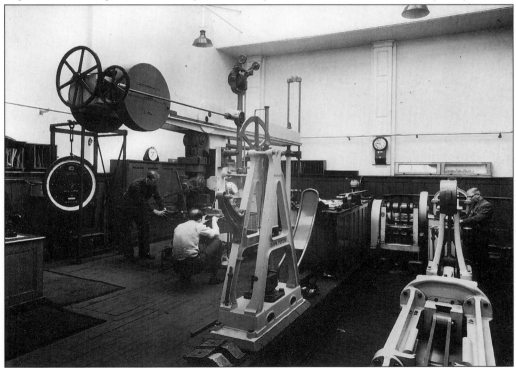

The Railway Works were also responsible for the manufacture and repair of all the ropes, chains and cables used by the GWR. This photograph taken in the 1950s shows the Chain Test House, where chains and ropes could be tested to breaking point.

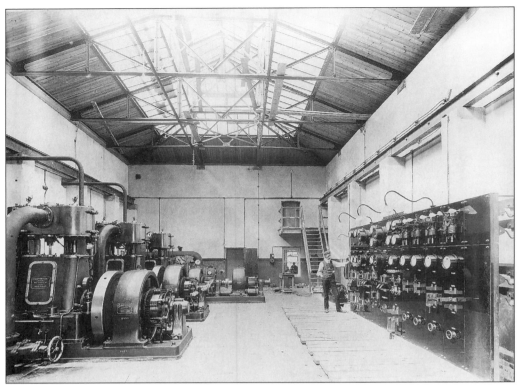

The 'M' Electric Power House around 1905.

The construction of the new Gas Holder for the Company's Gas Works in Iffley Road in 1924. In the background houses under construction in Ferndale Road can be seen, and beyond them open fields now covered in houses in the Cheney Manor area.

One perk gained from working for the GWR at Swindon was that good quality scrap timber could be acquired very cheaply. Timber could be collected at the Wood Wharf situated at Whitehouse Bridges. Timber was dispatched down the chute seen in the middle of the picture.

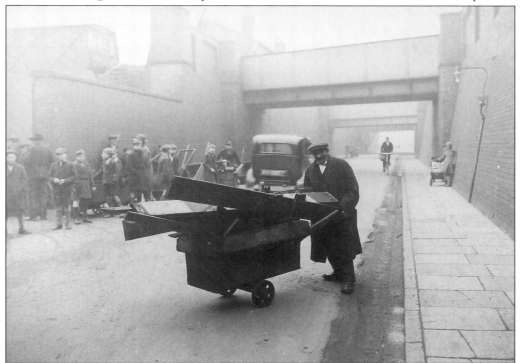

The scene at the bottom of the chute, in a view taken in 1934. The railway origins of the handcart are betrayed by the wheels which appear to have come from a platform sack truck!

The 'X' Shop at Swindon was where much of the complicated pointwork for track formations was built. This 1908 view shows a crossing made for Llanelly in South Wales.

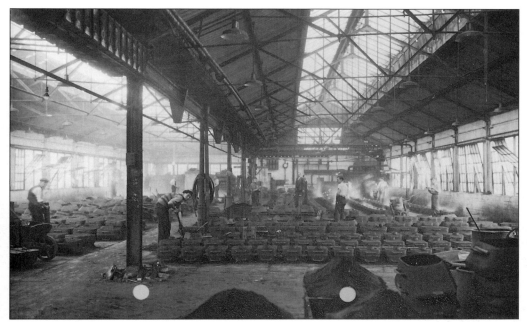

The interior of the Chair Foundry at Swindon, where cast iron track chairs were manufactured.

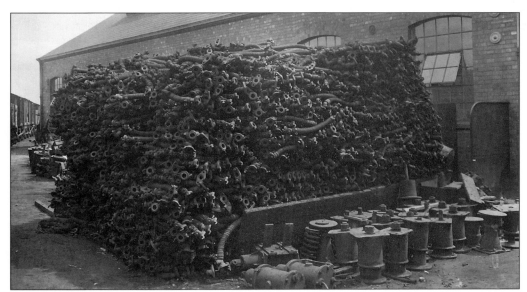

An enormous pile of steam and vacuum pipes for locomotives and rolling stock awaiting repair at Swindon in July 1933.

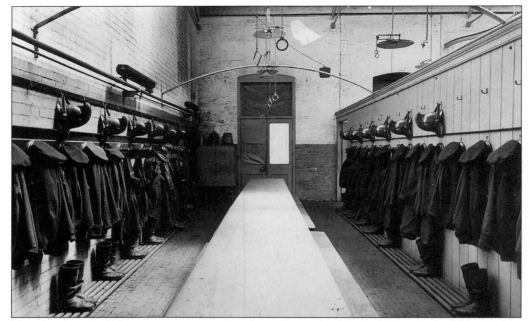

The Works was such an enormous undertaking that it had its own Fire Station, situated in Bristol Street. The photographer has recorded the neat rows of uniforms and hats in this 1930s picture.

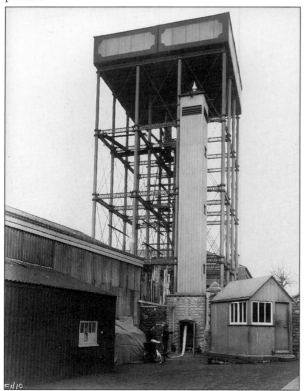

Although the large water tower, used to store water brought from Kemble by pipeline dominates this picture, it was in fact taken to illustrate the smaller tower used by the GWR Fire Brigade to hang up their hoses to dry.

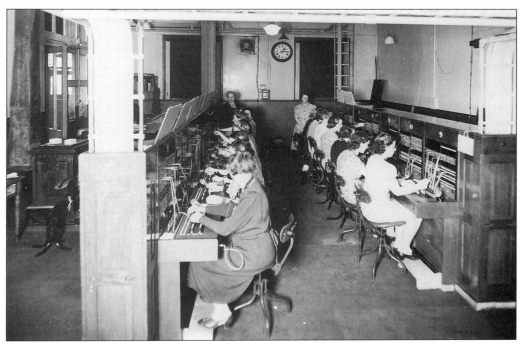

The interior of the Works Telephone Exchange, seen in the 1950s.

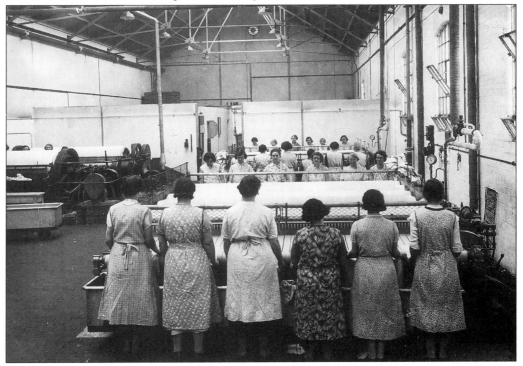

The GWR Laundry, seen in 1923. This facility was used to wash all towels, linen and other material used in such locations as Refreshment Rooms and Restaurant Cars.

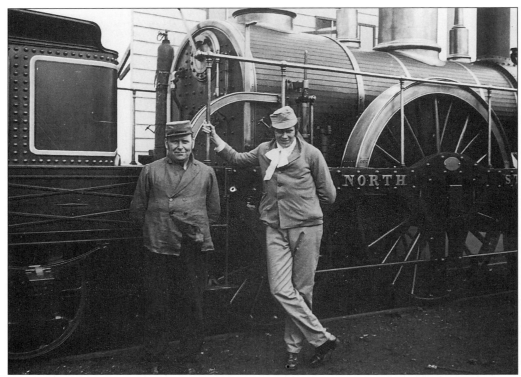

Another view of the *North Star* replica. This snapshot was taken during the filming of the GWR Centenary film in 1935, when the engine was used in the recreation of the opening of the line in 1838. The driver on the right of the picture is the late Gordon Bond.

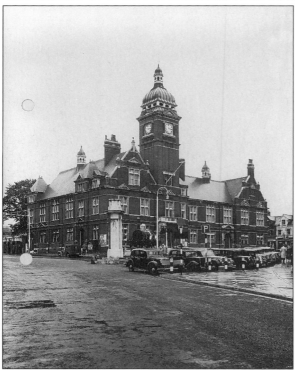

North Star was certainly a well-travelled engine; in September 1950 it was displayed outside the Town Hall in Regent Circus to publicise an industrial exhibition in the town.

Five
Swindon Works at War

During both world wars, the railway workshops played a vital role in the war effort both in the production of munitions and the construction and conversion of rolling stock such as ambulance trains. Since this book was published in the year which marked the 50th anniversary of the end of the Second World War, it is fitting that these pictures should therefore be included.

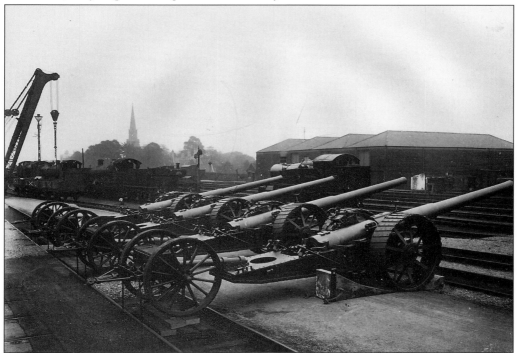

Six-inch Naval Guns produced in the Works during the First World War, seen outside the 'A' Shop. In the background, the spire of St Mark's Church can be seen.

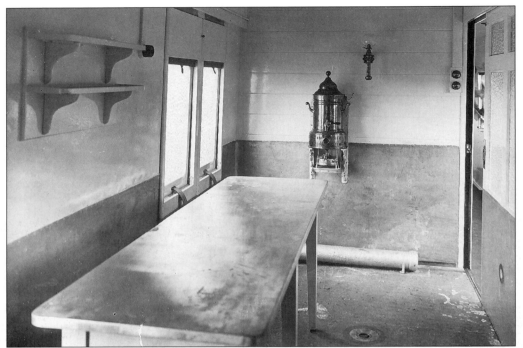

The rather spartan treatment room of Ambulance Train No. 16 photographed in March 1916.

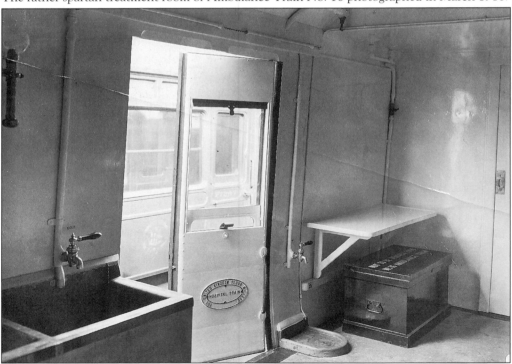

The Kitchen Car of the same train. This particular train was funded by the United Kingdom Flour Millers, as the cast plate on the door panel indicates.

A posed publicity photograph of Continental Ambulance Train No. 16 taken at Swindon in 1916 just prior to its export overseas.

A number of 16-inch Naval guns were stored at Swindon in the 'A' Shop during the Second World War. This picture taken on 24 March 1944 shows the gun ready for movement to an unknown location.

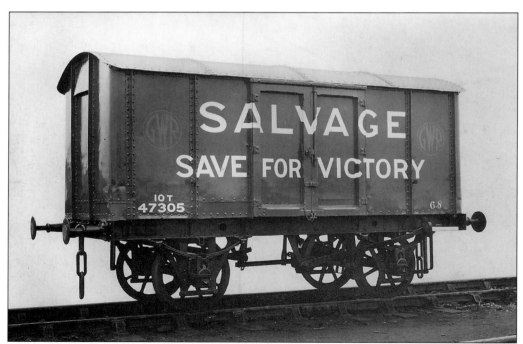

A Swindon picture of the Iron 'Mink' vans used by the Company in their drive to salvage as much waste as possible for the war effort. Painted bright blue, these vans toured stations on the system collecting waste of all kinds.

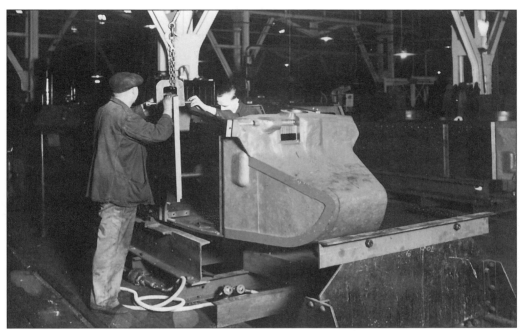

The production of 25 ton tanks in the 'AE' Shop in February 1941.

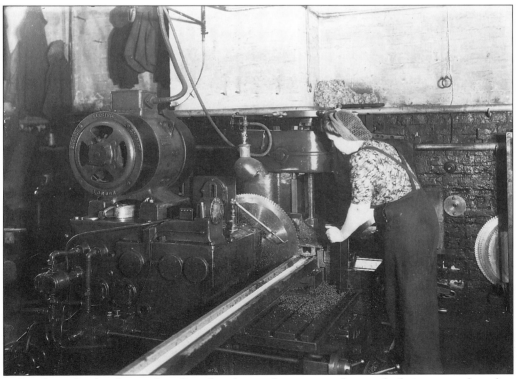

A female worker hard at work at Swindon during the war period; note the hair net use for safety purposes.

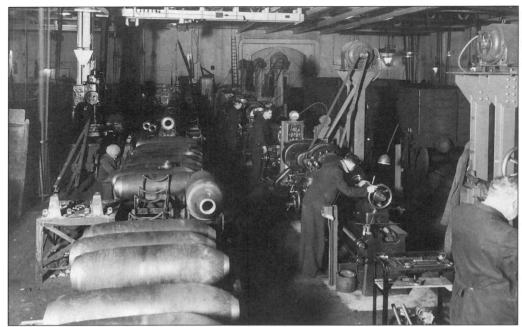

The 'X' shop already mentioned, was used for the manufacture of 1000lb bombs. This 1941 photograph shows the assembly line.

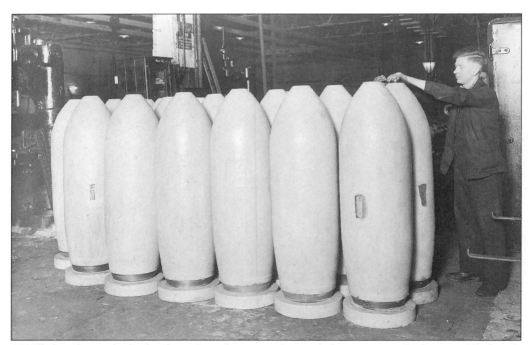

1000lb bombs ready for loading. Swindon manufactured the casings, which were filled with high explosive elsewhere.

Work being done on 2 pounder Mark VII
gun mountings. Photographed on
29 September 1942.

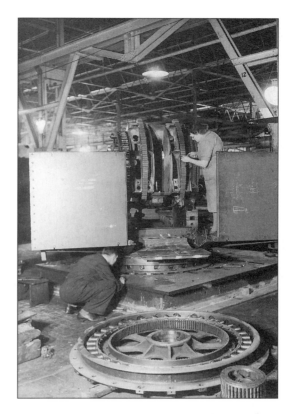

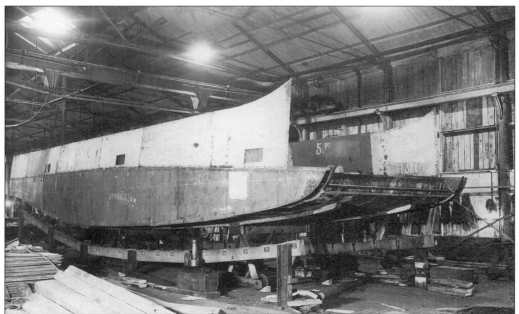

As part of the preparations for the opening of a Second Front in Europe, Swindon built Motor
Landing Craft for the Admiralty. This picture was taken in 13 Shop in April 1942.

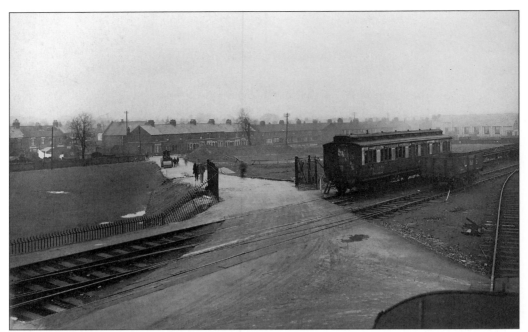

Short Brothers, who had aircraft production facilities elsewhere in Swindon, occupied part of 24 Shop in the Carriage Works. This 1941 view shows the Entrance to their workshop, with Ferndale Recreation Ground in the background.

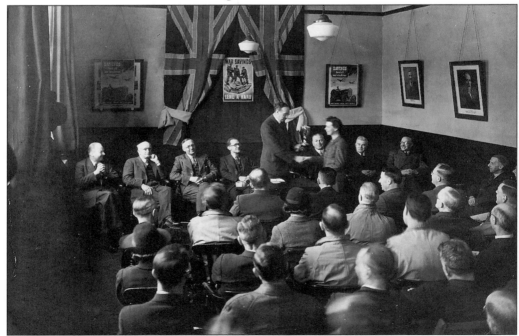

An important part of the War effort was the setting up of War Savings Groups, which existed all over the GWR network. In this photograph taken in April 1944, the Chief Mechanical Engineer F.W. Hawksworth is presenting a War Savings Trophy.

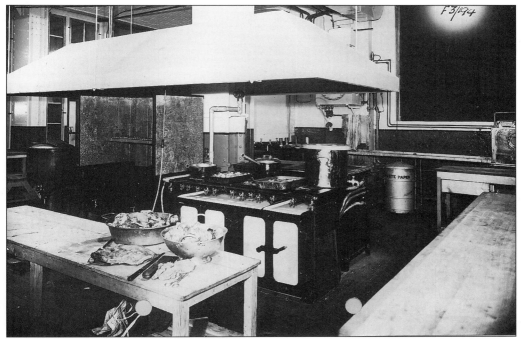

The kitchen of the Locomotive Department Canteen situated in the basement of the Water Tower close to Rodbourne Road, in February 1942.

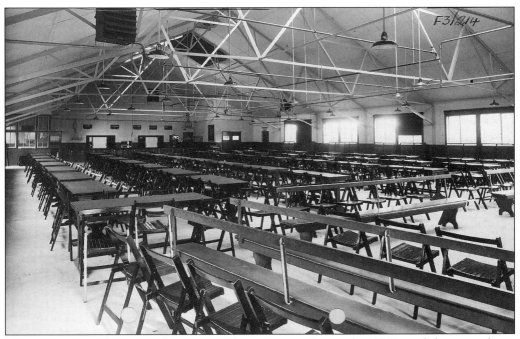

The Carriage Works acquired its own works canteen in September 1943, and this view shows the new facilities just prior to opening.

Considering its size and strategic importance, Swindon Works escaped very lightly from the attention of German bombers. In a raid on the town on 20 December 1940 however, bombs missed the works, and hit this house in Beatrice Street virtually demolishing it.

In the same raid, some damage was caused to rolling stock in nearby sidings, as this photograph indicates.

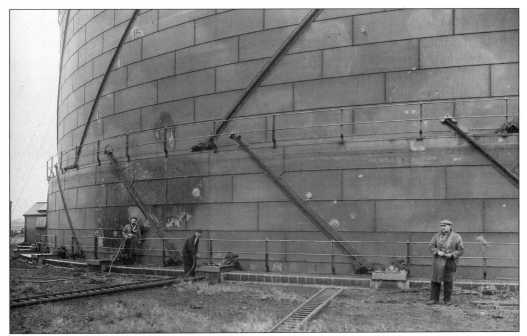

In another raid, on 27 July 1942, a German Bomber attacked the Works, causing some damage, which included the machine gunning of the gas holder. Prompt work by staff in plugging the bullet holes prevented the potentially serious consequences of such an attack.

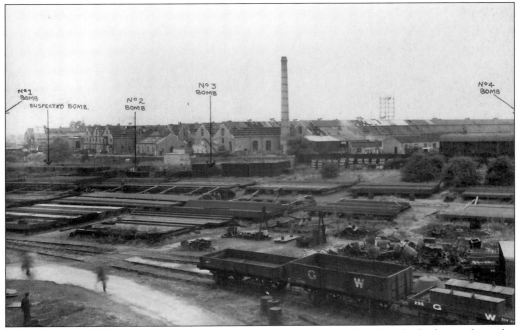

A print made by the Drawing Office, showing the locations of bombs which dropped on the works during the attack.

Swindon was also called on to repair rolling stock and locomotives damage in air raids elsewhere; this carriage was damaged in a raid on Southampton on the night of the 7/8 July 1941.

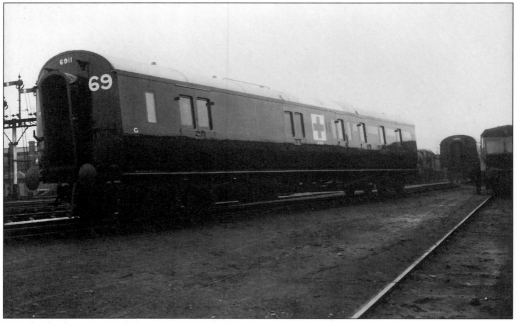

A vehicle from one of the Home Ambulance Trains assembled by the GWR in the Second World War, photographed in February 1945.

Six
Swindon Locomotive Shed

This section contains pictures of the large engine shed at Swindon, which was situated close to the works, and also some portraits of some of the famous and not so famous engines produced by Swindon.

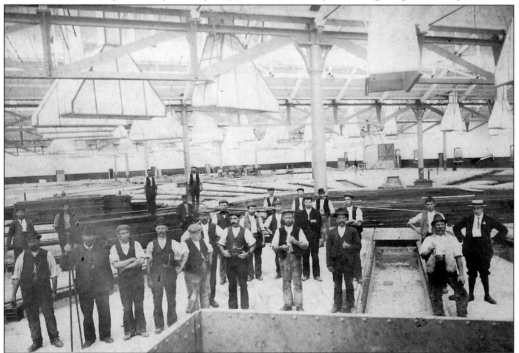

An early picture during the construction of the roundhouse section of Swindon Locomotive Shed, when added to the rest of the building in 1908.

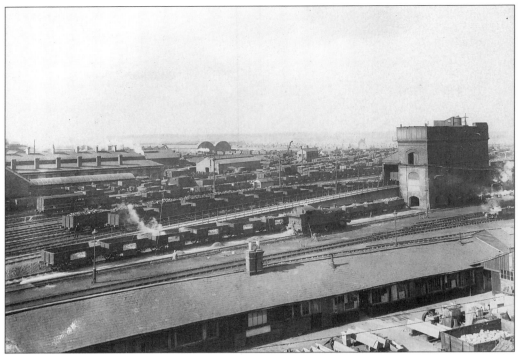

A 1943 view of the coaling stage and water tower of the shed, with the North Yard of the Locomotive Works in the background.

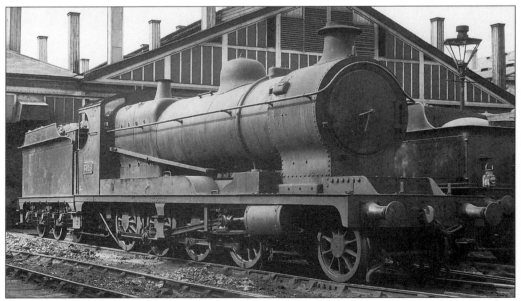

'ROD' 2–8–0 No. 3016 seen outside Swindon Shed in the 1930s.

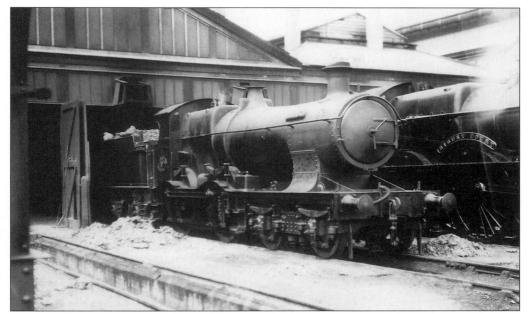

'Bulldog' class No. 3340 *Camel* seen outside the shed on 12 June 1932.

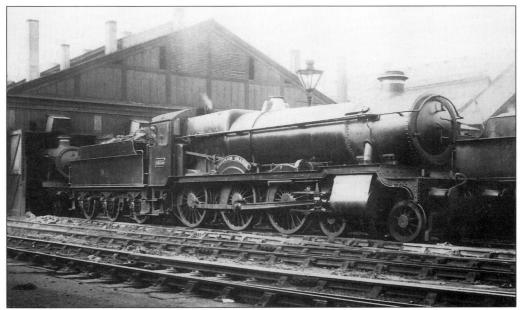

4–6–0 No. 6835 *Eastham Grange* pictured at Swindon on 14 May 1938.

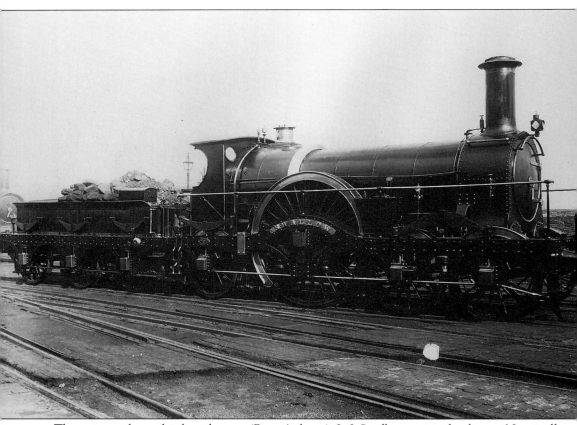

The paintwork on this broad gauge 'Rover' class 4–2–2 *Swallow* positively gleams. Nominally rebuilds of Gooch's original 'Iron Duke' class, locomotives of this type hauled most of the important express services on the GWR until the abolition of the broad gauge in 1892.

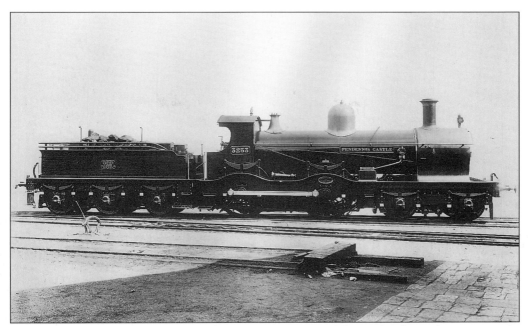

A beautiful sepia view of 'Duke' class 4–4–0 No. 3253 *Pendennis Castle* in almost ex-works condition.

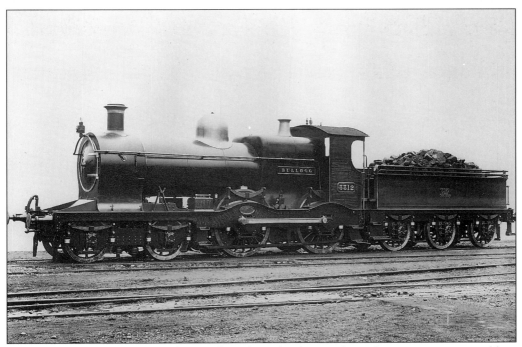

4–4–0 No. 3312 *Bulldog*. The cleaners have been hard at work on the engine, as its sparkling condition shows.

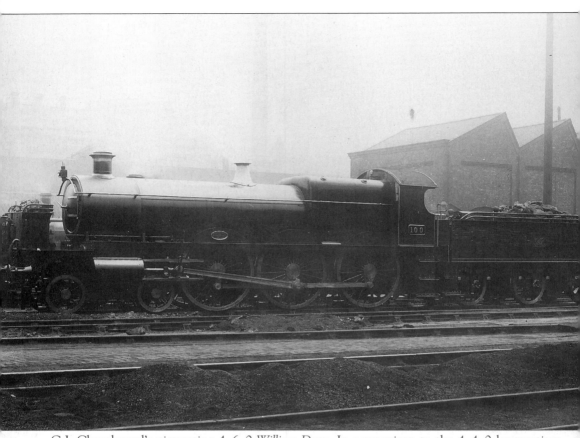

G.J. Churchward's pioneering 4–6–0 *William Dean*. In comparison to the 4–4–0 locomotives previously illustrated, the design looks very modern and stark.

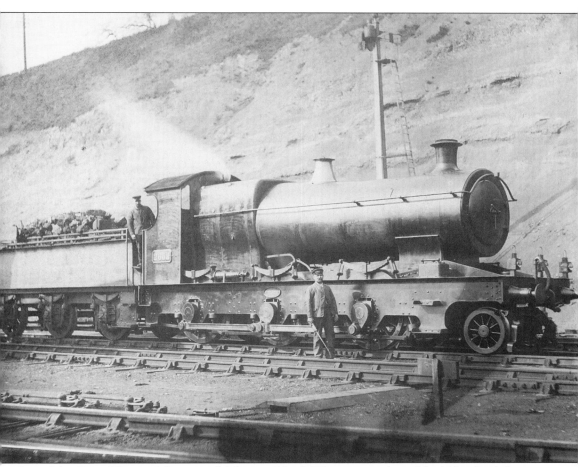

One of the Great Western's less graceful designs; No. 2652 was a member of the 'Aberdare' class so named since they were intended to haul coal trains from South Wales.

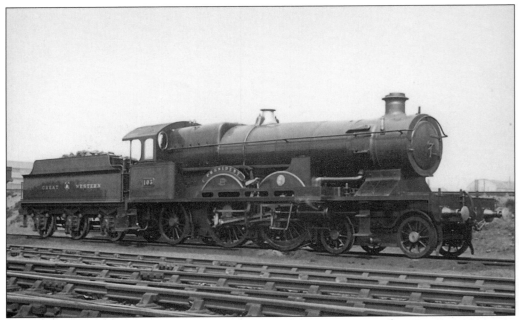

4–4–2 No. 103 *President*, one of three engines bought from France by Churchward to test against his own 'Star' and 'Saint' designs. This view dates from the 1920s when the engine had been extensively rebuilt with a GWR pattern boiler.

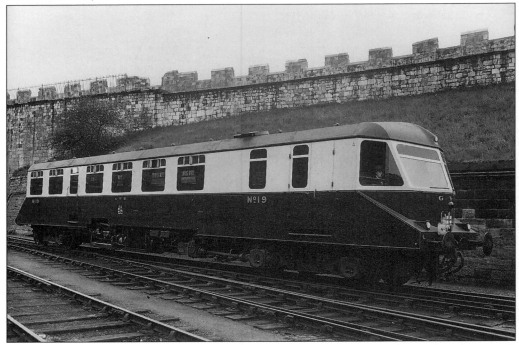

An earlier view showed a GWR Diesel Railcar under repair in the 'A' Shop. This photograph shows one of the later Swindon-built examples far from home in York, when on loan to the London & North Eastern Railway in May 1944.

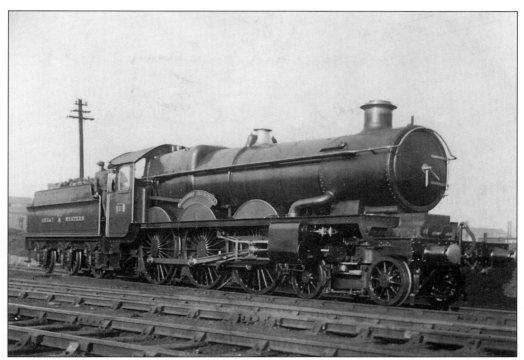

4–6–0 'Castle' Class No. 111 *Viscount Churchill*, the result of the rebuilding of Churchward's pioneering pacific locomotive *The Great Bear*.

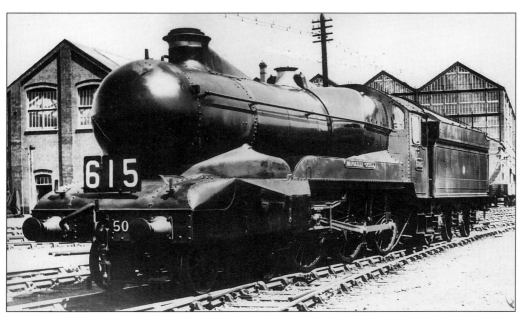

In the 1930s the GWR flirted with the idea of streamlining its locomotives. Two engines were modified, but as this picture of No. 5005 *Manorbier Castle* shows, the results were less than successful.

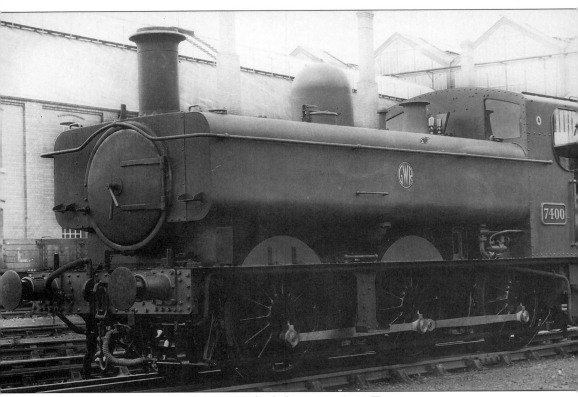

GWR 0–6–0 *Pannier Tank* No. 7400 built for use on Auto Trains.

Seven
Great Western Swindon

Swindon has always been known as a Railway Town, and in this part of the book, pictures showing the activities of the Mechanics Institute, the GWR Medical Fund, and the other social institutions available for railway staff and their families are shown. Also included are some of the social and sporting activities enjoyed by Swindonians over the years.

The premises occupied by W.J. Knee, on the corner of Emlyn Square and London Street, taken by the Works photographer in September 1929.

The front garden of 34 Faringdon Road, as seen before the railway village was modernised. This cottage has now been converted into a museum, showing life in the village around 1900.

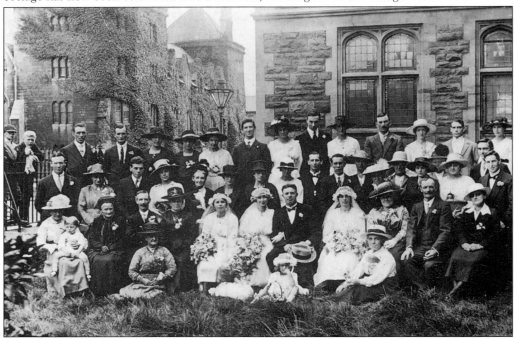

A wedding party in the garden of the Mechanics Institute around 1920. In the background can be seen the Wesleyan Methodist Church, now the GWR Museum.

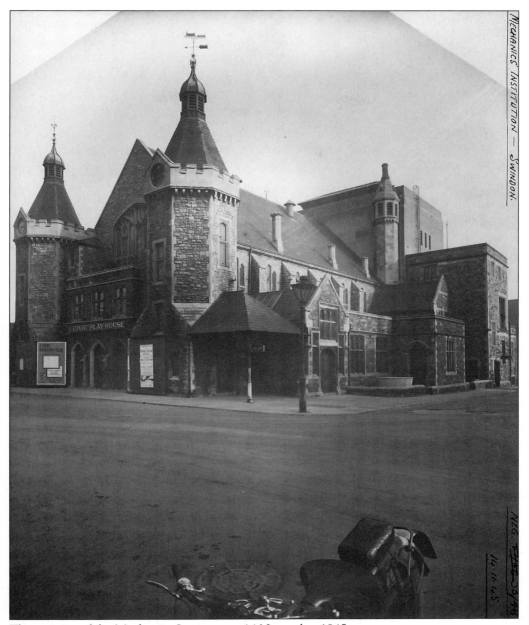

The exterior of the Mechanics Institute on 14 November 1945.

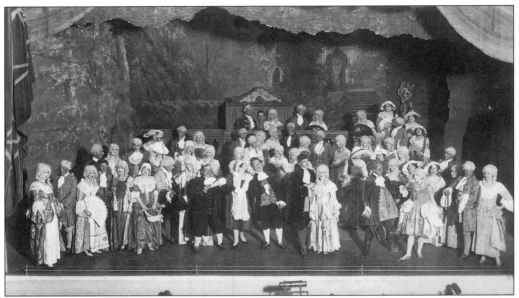

A production of *Tom Jones* held at the Mechanics Institute in 1927.

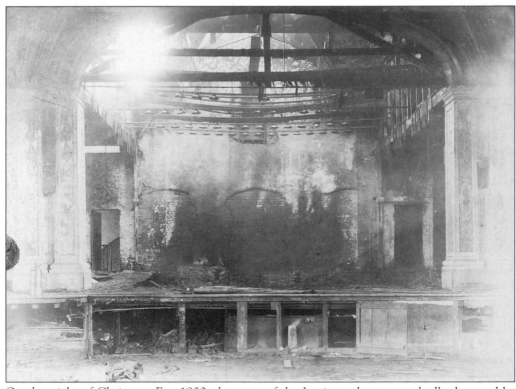

On the night of Christmas Eve 1930, the stage of the Institute theatre was badly damaged by fire, as this photograph, taken a few days later, shows.

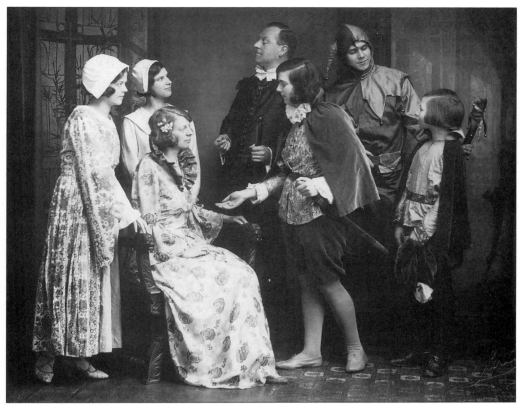

The cast of the *Swindon GWR Shakespearean Party* which won the Hugh Mytton silver cup at the Social & Educational Festival at Cardiff in March 1930.

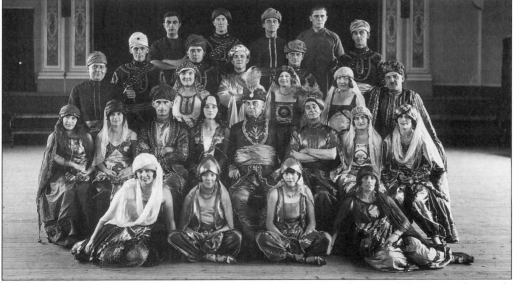

The cast of *A Trip to Juja* in front of the stage at the Mechanics Institute. This musical comedy was toured all around the GWR system.

The GWR Staff Gleemen seen outside the Institute in the 1920s. This choir was very well known, cutting a number of records, and broadcasting on the BBC on numerous occasions.

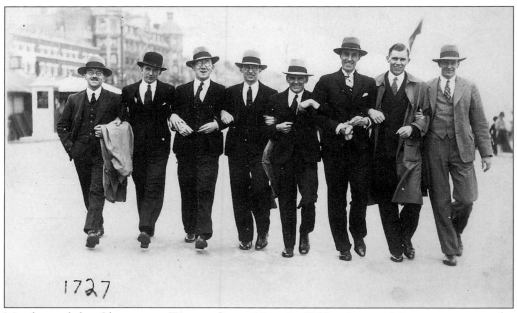

Members of the Gleemen at Weston Super Mare in 1930 prior to giving a concert at the Pavilion.

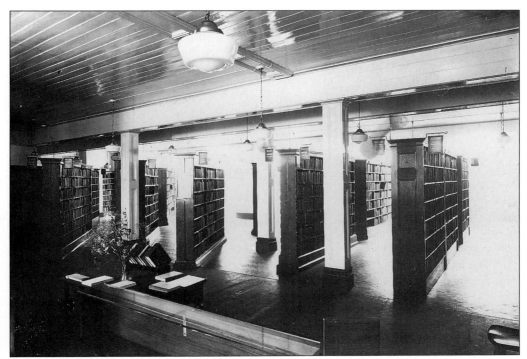

The well stocked shelves of the Institute Library on 21 August 1931.

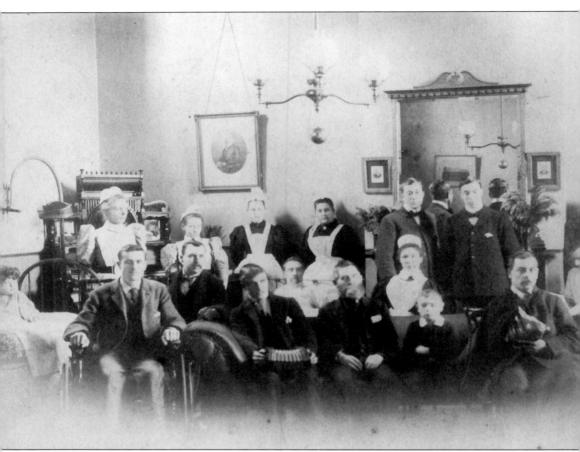

A very early picture of staff and patients at the GWR Hospital. The little child on the far left of the picture was Ernest Hobbs, later to be the Hydraulic House Attendant, and operator of the famous works hooter.

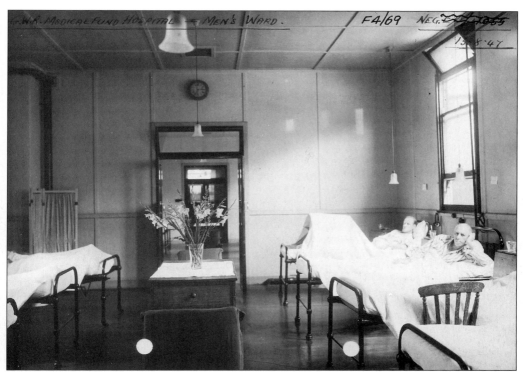

The Mens Ward of the GWR Hospital in August 1947.

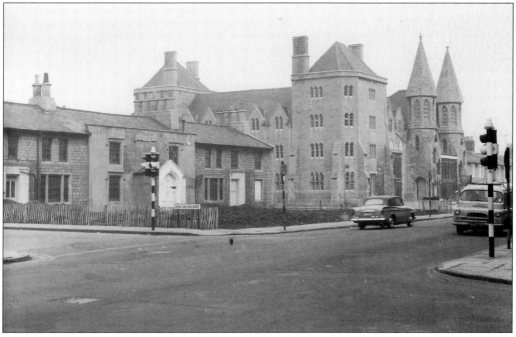

By the time this photograph had been taken in 1965, the GWR Hospital had been closed. In due course the building was converted into a local community centre.

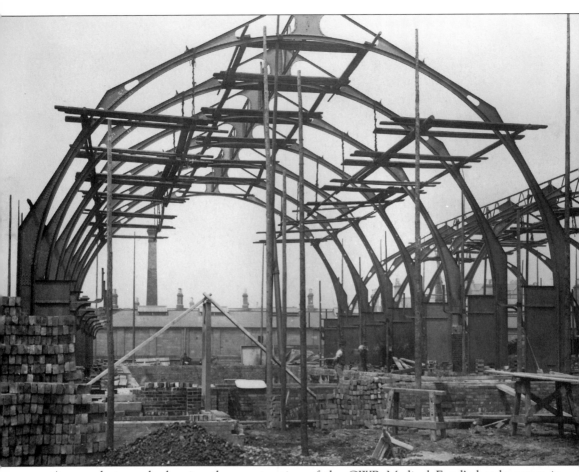

A rare photograph showing the construction of the GWR Medical Fund's headquarters in Milton Road in 1892. It goes without saying that the girders for the roof were manufactured by the Company in the Works.

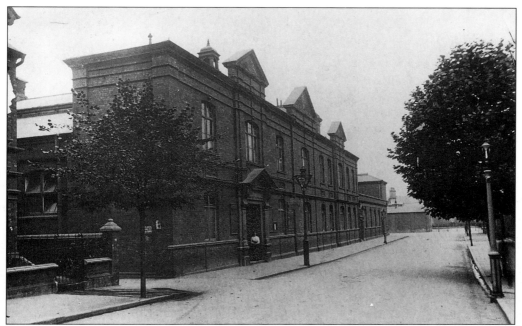

The exterior of the new building just after opening in 1892; note the mature trees in Milton Road, now sadly gone.

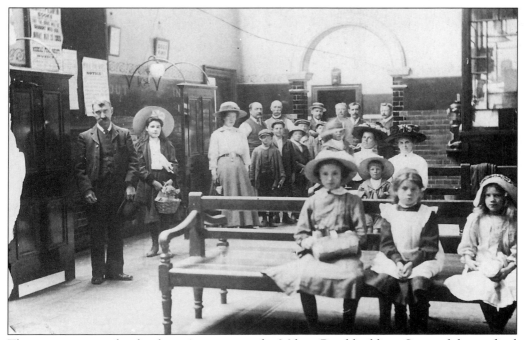

The waiting rooms for the doctor's surgery in the Milton Road building. Some of the medical staff can be seen in the background of the picture, taken at the same time as the previous one.

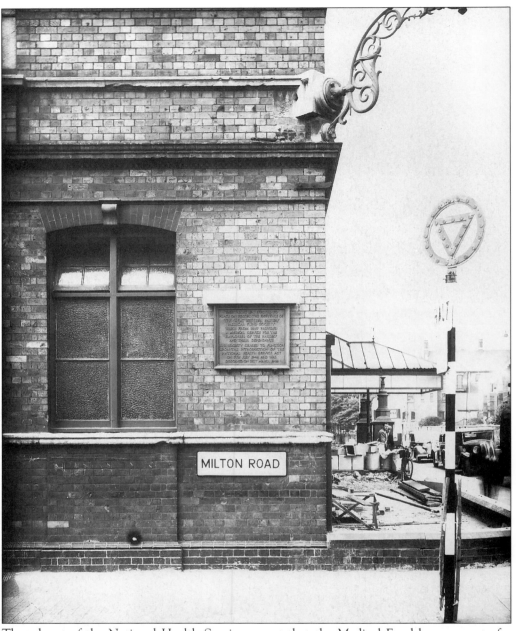

The advent of the National Health Service meant that the Medical Fund became part of a much bigger 'Cradle to Grave' system. A plaque commemorating the achievements of the Fund was fixed to the wall in Milton Road and can be seen here in this 1947 picture.

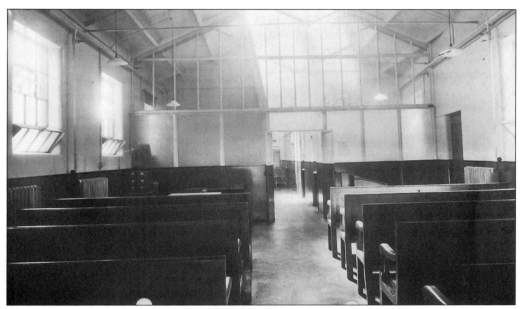

The Outpatients Department of the GWR Medical Fund seen in July 1947.

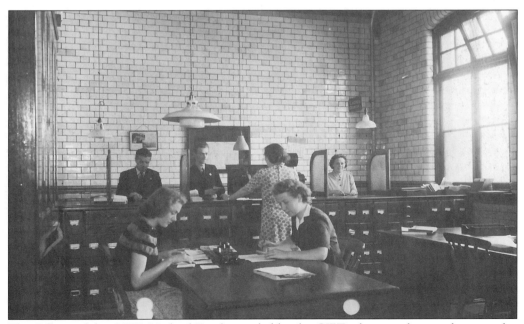

The Offices of the GWR Medical Fund recorded by the GWR photographer on the same day 11 August 1947.

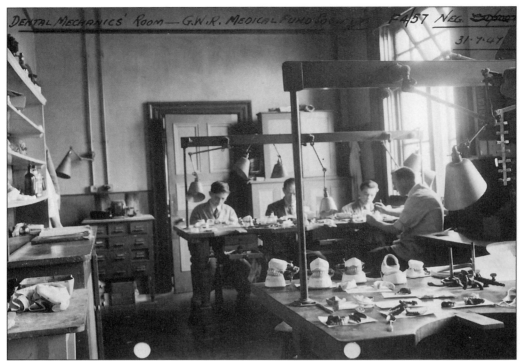

Products of the Dental Mechanics Room can be clearly seen on the bench in the foreground of this picture again taken in 1947.

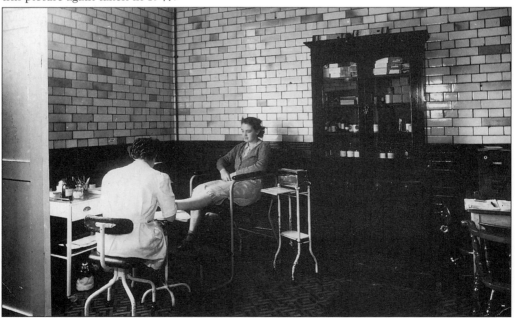

The tiled walls of the Milton Road Building seem rather cold by today's standards, but the quality of treatment given more than made up for this. Here the Medical Fund chiropodist is at work.

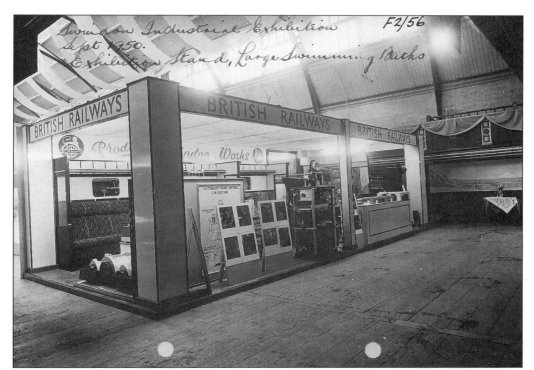

The Large Swimming Baths in the Milton Road complex could be boarded over for special events and social activities, and had in fact been used as a dressing station during the Great War. This stand was part of the 1950 Swindon Industrial Exhibition held at Milton Road already mentioned earlier in the book.

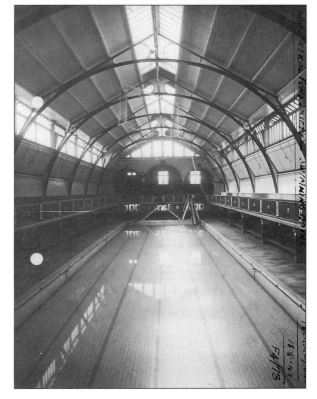

The Large pool in normal use on 18 August 1947.

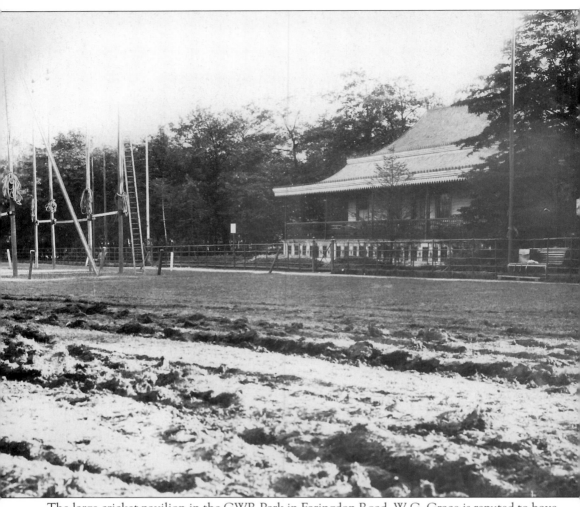

The large cricket pavilion in the GWR Park in Faringdon Road. W.G. Grace is reputed to have been out for a duck on the cricket pitch here!

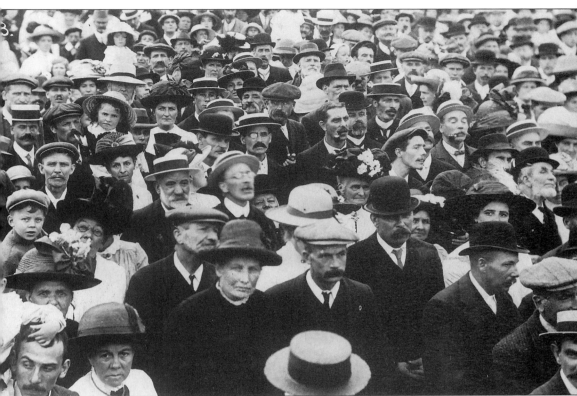

Many people remember the GWR park as the site of the GWR children's fête, held annually for many years. Up to 25,000 people crowded into the park, and children were given a slab of fruit cake, and a ticket for a ride on the fairground attractions provided. This picture was actually taken on the occasion of a Liberal Party fête, sometime before the Great War. Close examination of the picture has shown that William Stanier, pictured earlier in the book, can be seen smoking a pipe in the centre of the crowd.

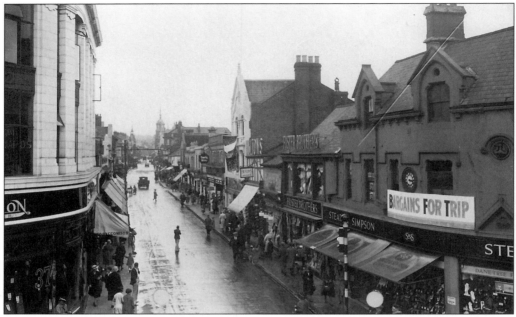

Such was the importance of the Swindon 'Trip' holiday, that shops made special efforts to get as much trade as possible before around 25,000 people deserted the town for up to two weeks. The works photographer has taken this picture of Bridge Street on 'Trip Friday', and Stead & Simpsons shoe shop are advertising bargains for the coming holiday.

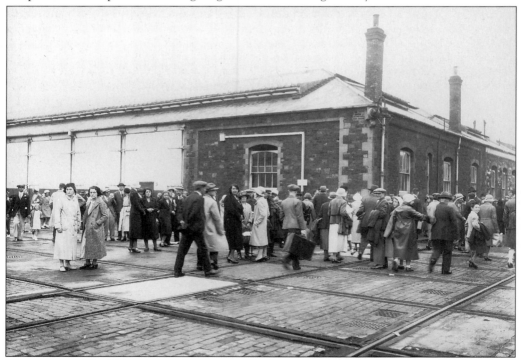

The scene on 'Trip' Morning at the carriage Works, with trippers awaiting their trains.

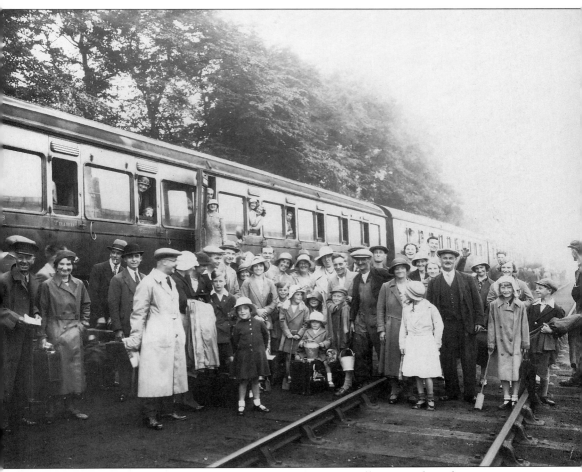

One of the most talked-about pictures in the GWR Museum collection; when this image was used as an advertising poster, many Swindonians were pleased to find relatives pictured in this 1930s photograph of trippers prior to departure.

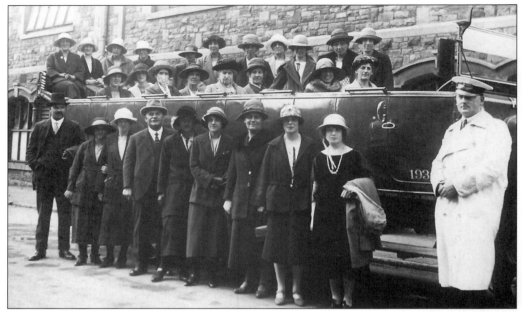

The ladies of the Polishing and Sewing shop ready to depart on their annual outing, with Foreman A. Pennell in attendance.

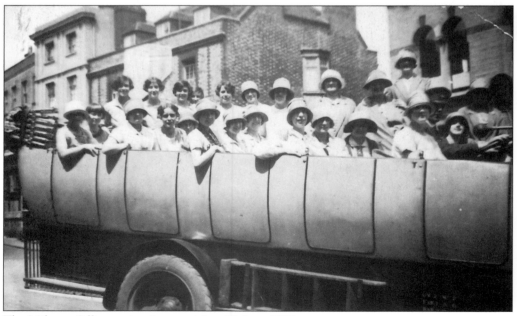

The Mileage Office outing 'in transit' on 22 June 1927.

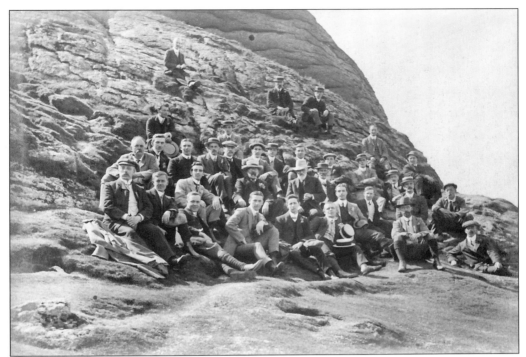

A group of staff from the Accounts Office pictured on their 1911 staff outing at Haytor.

A later photograph of the Accounts Department outing, pictured this time at Teignmouth in the 1930s.

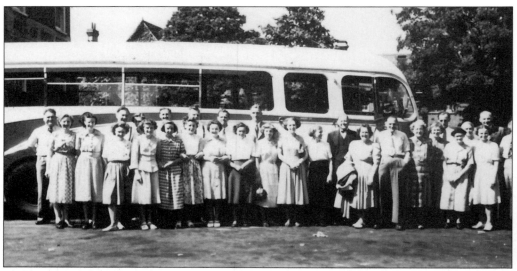

The mode of transport is somewhat more sophisticated for the Ledger Office outing to Newbury and Windsor on 10 June 1950.

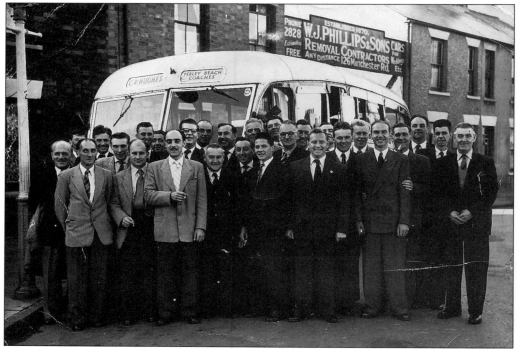

Another outing, this time for staff from the 'A' shop, pictured in Manchester Road. No date for this event is unfortunately given.

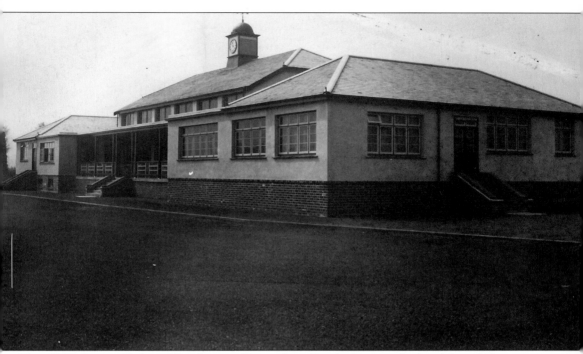

The GWR Sports Club and Pavilion at Shrivenham Road, photographed in May 1935, soon after opening.

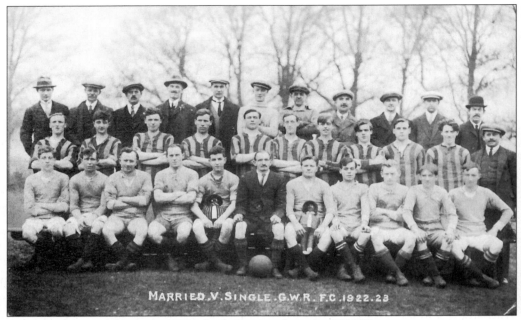

A postcard view of these two GWR football teams from the 1922/23 season.

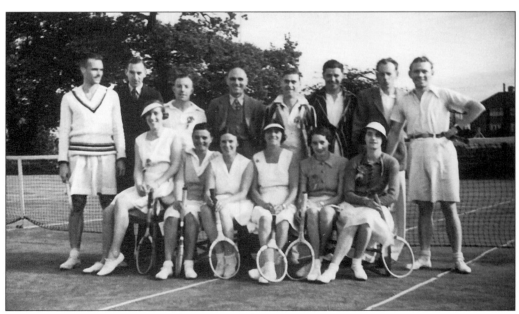

Members of the GWR Tennis Club, seen at Shrivenham Road in 1936.

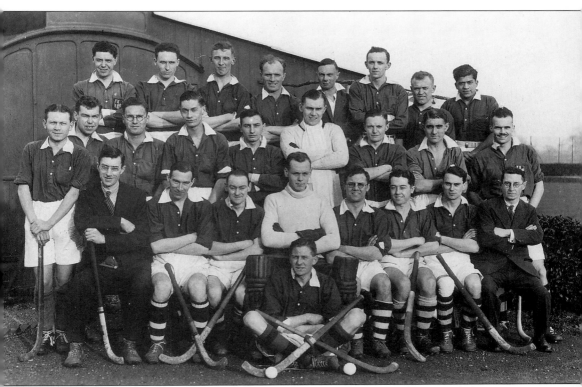

Founder members of the GWR Hockey club, again pictured at Shrivenham Road this time in 1934. Note the use of an old coach body as changing facilities.

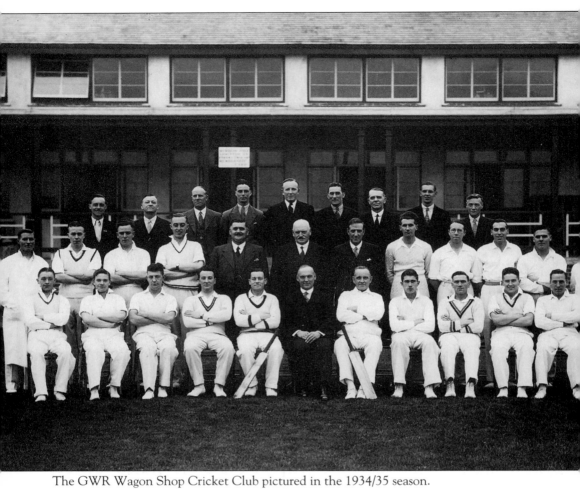

The GWR Wagon Shop Cricket Club pictured in the 1934/35 season.

The GWR Cricket Club photographed by Maylott's well out of the cricket season in November 1951.

The Swindon Works Motor Club Officers and Committee for 1932/33. The President was C.T. Cuss, and the Secretary A.E.W. Treherne.

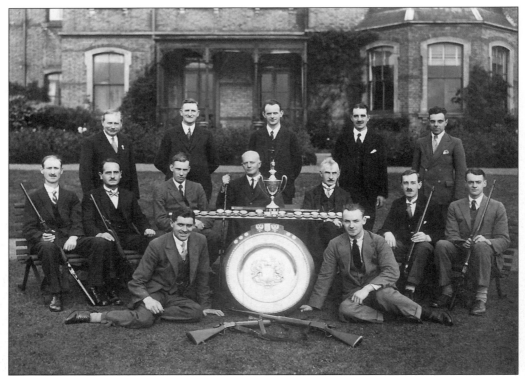

The GWR (Swindon) Social & Educational Union Rifle Club, pictured in 1929 after winning both the Landsdowne Challenge Shield, and the Wiltshire Times Cup. C.T. Cuss, President of the Motor Club, was also Chairman of this body!

The GWR Staff Association Club in Holbrook Street, photographed in May 1945.

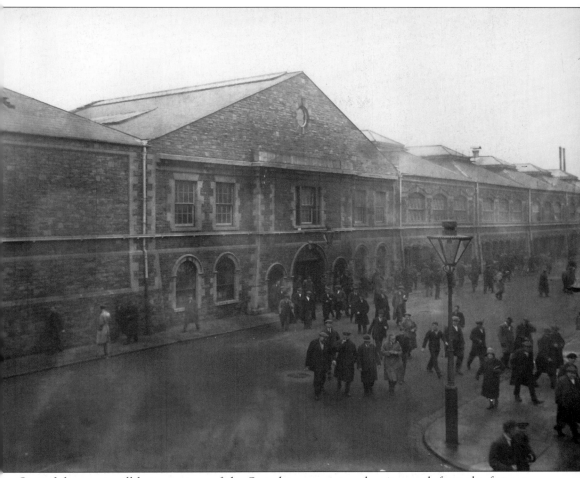

One of the most well known views of the Swindon scene; men leaving work from the famous 'Tunnel Entrance'. This picture was taken on the 16 January 1935.

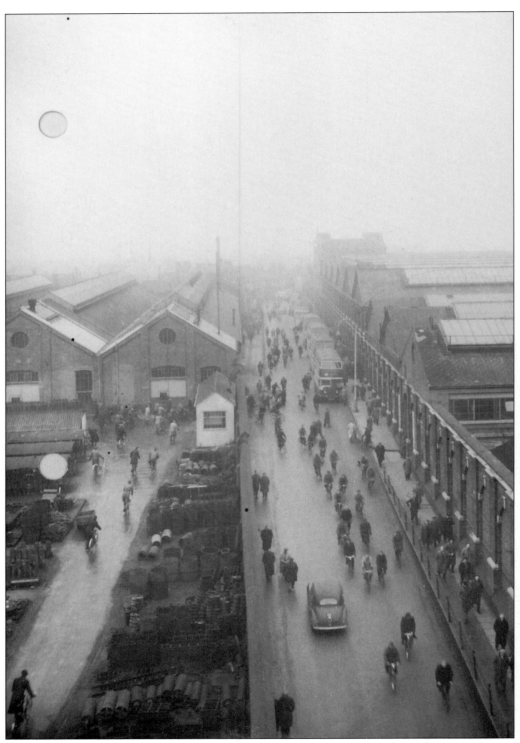

A less well known view of the lunchtime 'rush hour' in Rodbourne Road in February 1954.

Eight

Great Western
Preserved

With the enormous influence of the Great Western at Swindon in mind, it was fitting that British Rail and Swindon Borough Council should chose the town as the site of a museum to celebrate 'God's Wonderful Railway'. Opened in 1962, the museum will hopefully be moving from its cramped town centre location into larger buildings on the old Swindon Works site in 1997.

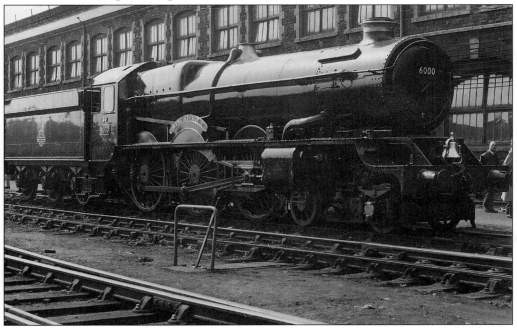

One of the most famous locomotives ever built by the GWR at Swindon. No. 6000 *King George V* was constructed in 1927, and pioneered the 'Return to Steam' of preserved locomotives in the 1970s. It is now the star exhibit in the GWR Museum.

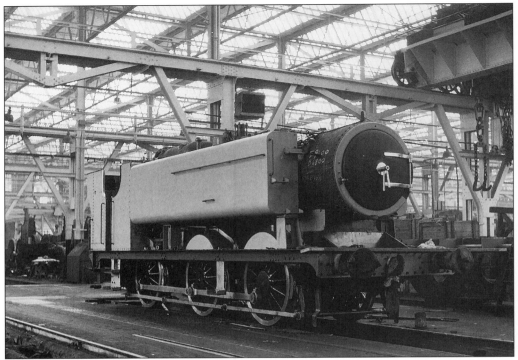

0–6–0 Pannier Tank No. 9400 undergoes restoration in the 'A' Shop at Swindon Works, prior to its installation in the GWR Museum in 1962.

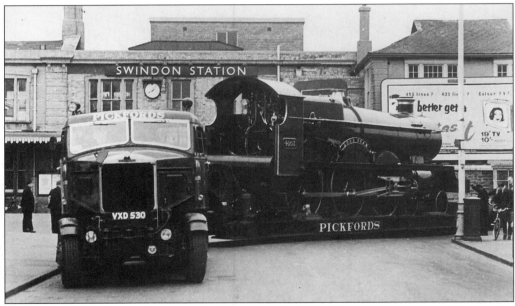

The movement of locomotives into the Faringdon Road building was not an easy affair, and in ensuing years, matters have not improved! 4–6–0 No. 4003 *Lode Star* is inched around the corner by the Great Western Hotel in Station Road, on its way to Faringdon Road in the spring of 1962.